Practical Color Management

EDDIE TAPP
On Digital Photography

Eddie Tapp

O'REILLY®

BEIJING • CAMBRIDGE • FARNHAM • KÖLN • PARIS • SEBASTOPOL • TAIPEI • TOKYO

Practical Color Management BY EDDIE TAPP

Published by O'Reilly Media, Inc., 1005 Gravenstein Highway North, Sebastopol, CA 95472.

O'Reilly books may be purchased for educational, business, or sales promotional use. Online editions are also available for most titles (*safari.oreilly.com*). For more information, contact our corporate/institutional sales department: **800.998.9938** or *corporate@oreilly.com*.

Editor: **Colleen Wheeler**

Technical Editor: **Jon Canfield**

Production Editor: **Adam Witwer**

Proofreader: **Sanders Kleinfeld**

Indexer: **Julie Hawks**

Cover Designer: **Mike Kohnke**

Interior Designer: **Ron Bilodeau**

Print History:

October 2006: First Edition.

ISBN-10: 0-596-52768-3
ISBN-13: 978-0-596-52768-6

[F]

In loving memory of Dean Collins—
friend, advisor, inspiration, and educator

Contents

Introduction

Who Is This Book Written For?

I travel a great deal, teaching students around the world, and I've found that what they need is straightforward, plain-language instruction that will help them solve their own problems. In this book, I hope to help you solve digital-imaging and -processing issues by showing you color management concepts that are easy to understand.

I don't want you to have to buy a huge doorstop book to find the information you need. The *Eddie Tapp On Digital Photography* series is designed to give you specific information on subjects such as using advanced production techniques, creating a color management workflow, controlling digital color and tone, and making creative enhancements.

This second book in the series, *Practical Color Management*, provides the basic information you'll need to get consistent color results from your digital files. In this technological era, it's easy to find yourself in what I call the "Abyss of the Digital Mass," a spherical object that encompasses all known elements of all things digital. Compared to the Digital Mass, the amount of knowledge most of us possess is but a few granules of sand. Sound familiar? But don't be the least bit intimidated or discouraged by this mass. Our job is to learn a single element at a time, and through education, implementation, and experience, these single elements will merge to form a greater understanding. From there, we will know that we can take some control of our own work.

Why Do We Need Color Management?

If we all had one type of camera, computer operating system, image-editing application, and output device, it would be extremely easy to set up a single system in which color would always come out the way you want it. But because we all have various hardware, software, and processing techniques, it's important to learn how to use the tools and theories of color management consistently so that our results can be predicted, and we aren't guessing in the dark. Here are the simple answers to the question of why we need color management:

- **To produce better color**

- **To reduce waste**

- **To be able to repurpose images**

- **To speed up production time**

- **To save money**

My Own Color Management Journey

Early on in my digital experiences, Don Stevenson, an accomplished commercial photographer and good friend, told me about ICC profiles and color management. Don had only read about the promise of ICC profiles but encouraged me to get involved. After a little investigation, I did just that. Chris Warner, then with Apple Computer, introduced me to what was then an innovative solution: the Color Tron by Lightsource. And it all started to come together.

A few years later, GretagMacbeth and Apple had a series of seminars on color management, showing instruments and preaching the advent of using ICC profiles. But there was never any real information on how to actually use these profiles. I was already using them with relative success but never knew if I was doing so properly or not, and I had hoped that these seminars would reveal any hidden secrets. Instead, I would always leave these (free) seminars knowing there were good instruments to use but never seeing how to actually implement them in a workflow. So I continued to create profiles using what I call "Back Door Profiling" with four-color printing and professional photo labs with great success.

The first publicized success story using profiles came from a project that Stephen Johnson (digital explorer and innovator) had worked on. He shared his calibrated monitor profile with a printer in Texas, which used the profile to view the proper rendition of color and tone and print fine art posters for Stephen. The next publicized success story was documented by *USA Today*.

All of this was in the mid-1990s, and anything beyond using the Adobe Gamma Control Panel to simulate a calibrated monitor for color management was Greek to most of us. It wasn't until Photoshop 5.5 came out that we could easily use ICC profiles for output conversion on both the Mac and Windows platforms. At that time, I decided to study ICC profiles more closely so that I could relate this information in my workshops. I started to preach the promise of profiles in all workflows. I found that by implementing three simple stages (covered in this book), it was possible to obtain predictable results from the printing press or even the photographic lab. However, achieving these results was a challenge because for this type of workflow to succeed, consistency with the printing devices had to be maintained, and there was a lot of fluctuation or inconsistency with some labs and print houses. At one point, a lab executive wrote to me and asked that I stop spreading the promise of color management in my workshops and seminars.

These days most of the photographic labs have implemented color management into their workflows, allowing us to partner with them and let them color manage our work.

As a photographer, educator, consultant, and trainer, I have had the opportunity to work with many corporations, government agencies, individual studios, professional photographic labs, and four-color printing houses in establishing and implementing color-managed workflows. And in doing this, I have come across many challenges. This brings me to my coauthor Rick Lucas, who has always been my primary color management guru. On many occasions I have called Rick while I was on-site, and he has always been able to walk me through the most difficult challenges. (It is an honor to have my color management guru work with me in writing this book.)

There was a time not too long ago when teaching color management in my workshops, while perhaps the most important topic, ended up being the least fun. This is no longer the case. Color management has

become a key element in the success of a digital workflow. Because 80 percent of imagers are now using some form of digital, they have acquired a fair amount of digital equipment and are demanding predictable and consistent results.

I have attempted to add workflow procedures within this book that partner up with a color-managed workflow. One workflow option that is not covered in a RAW workflow is Adobe's DNG (Digital Negative) format for preserving a variety of RAW files. DNG has the promise of allowing us to acquire today's RAW file formats years from now, even as operating systems and RAW processing software progress and change. I would encourage you to look at the DNG format for preservation of today's RAW files.

It is my hope that you will be able to take some of the concepts in this book, adapt them to a successful workflow with your work, whether you have a professional workflow or not, and enjoy the promise of color management.

Implementing Practical and Consistent Color Management

Here's a specific look at what the chapters will cover:

Chapter 1, The Search for Consistent Color

Even the earliest artists probably wanted some consistency to the colors they used. In this chapter, we'll take a quick look at how and why the concept of color management evolved.

Chapter 2, Understanding Key Color Management Concepts

What is the difference between calibration and profiling? What is the relationship between gamma and color space? In this chapter, we'll go over some key terms and concepts in color management.

Chapter 3, Establishing a Color Management–Friendly Workflow

Before you can implement color management concepts, you've got to have a digital workflow that supports best color management practices. In this chapter, we'll discuss preparing your files, from input to processing to output.

Chapter 4, Three Stages of Color Management

In this chapter, we'll break your basic color management scenarios down into their three stages: establishing your working color space, calibrating and profiling your devices, and converting to your output profile.

Chapter 5, Technically Speaking

With such a wide variety of equipment, hardware, and software scenarios to consider, it's helpful to have an expert on your side. In this chapter, color guru Rick Lucas takes you through some in-depth color management concepts.

Appendix, Additional Color Management Resources

As any color geek knows, there's always more to know about color management. Here we've listed a few resources for your further color management studies, notably an excerpt from the people who put together the Universal Photographic Digital Imaging Guidelines (UPDIG).

Consistency Conquers the Digital Mass

Color management is a sophisticated conglomeration of scientific computational algorithms, and it is not easy to grasp it all at once. The following pages are designed to help you understand the basics of how color management works and, more importantly, specifics of how certain type of workflows benefit from certain selections or settings.

As with any workflow, establish your settings and maintain consistency. (Have I used the word "consistency" enough here?) If your results are not predictable, analyze the area you think may be the problem and change a setting, color space, profile, or option, and come up with a solution that works for you.

In today's digital workflow, the ability to implement consistency has been greatly enhanced by the advent of color management. Over the past decade, manufacturers of equipment and software have increasingly allowed the implementation of color management options and controls, and there is every indication that, as technology progresses, using these controls will become easier and even more automated. Currently, it is possible to take a single image file and color manage this file to a host of different printers, including ink-jet, dye sub, laser, a professional lab, or a printing press, with matching results. The one thing you should demand in your workflow is predictable results, and color management can make that easier to obtain. Consistency is key; take the challenge. (There I said it again in case you missed it.)

Conventions

This book was written based on Photoshop CS2, although many of the tools have looked the same for a few versions now. Of course, certain chapters—such as Chapters 3 and 4, which touch on Adobe Bridge—are intended to address workflow needs specific to CS2.

This book is intended for both Mac and Windows users. Most of the tools and menus in Photoshop work about the same on both platforms. I'll call attention to those few specific differences, but in general, to accommodate both Mac and Windows readers, shortcuts are listed like this: Opt/Alt + Cmd/Ctrl + X, where the Mac key combination is listed first in each set of alternatives. Most Mac users know by now that they should Ctrl+click to bring up contextual menus when not using a two-button mouse.

Safari® Enabled

When you see a Safari® Enabled icon on the cover of your favorite technology book, that means it's available online through the O'Reilly Network Safari Bookshelf.

Safari offers a solution that's better than e-books. It's a virtual library that lets you easily search thousands of top tech books, cut and paste code samples, download chapters, and find quick answers when you need the most accurate, current information. Try it for free at *http://safari.oreilly.com*.

How to Contact Us

Please address comments and questions concerning this book to the publisher:

O'Reilly Media, Inc.

1005 Gravenstein Highway North

Sebastopol, CA 95472

800-998-9938 (in the United States or Canada)

707-829-0515 (international or local)

707-829-0104 (fax)

We'll list errata, examples, and any additional information at:

http://www.oreilly.com/catalog/colormgmt

To comment or ask technical questions about this book, send email to:

bookquestions@oreilly.com

For more information about our books, conferences, Resource Centers, and the O'Reilly Network, see our website at:

http://www.oreilly.com

Acknowledgments

First, I want to thank Rick Lucas, my coauthor for this book, because he has always been available to me and makes many complicated issues seem so easy. Thank you, Rick, for sharing and writing with me.

I would like to thank the many sponsors for having confidence in me and supporting my educational efforts.

Always a special thanks and hug to Scott Kelby (the world's best and fastest book writer) for his sincere yet humorous encouragements, and Jeff Kelby for his confidence in me to become a Photoshop World Dream Team member.

A heartfelt thanks to Dave Mets, David Sparer, Steve Inglima, and all of the Canon reps, who are so encouraging to me in so many ways as an Explorer of Light and Print Master with Canon.

Thanks to all of the models and image contributors who grace this book (their names are included within), especially the amazing artist Bert Monroy for his yellow submarine on page 61 of my first book (since I forgot his credit line).

A special thanks to artist Edgar Lituma, who created graphics for this book, including the scanner and monitor graphics.

My editor Colleen Wheeler at O'Reilly, who totally rocks, is so smart and insightful, and her contributions have been instrumental in organizing the subject matter covered in this book. She has been my teacher in so many ways. My technical editor Jon Canfield has also brought much-needed clarity to this project. I'd like to thank everyone else at O'Reilly who has helped to bring this book to fruition, especially Steve Weiss for conceptualizing this project series, and recognizing and believing in me.

Thanks for the help and loving support from Andy Hern, Becky and Randy Hufford, Steve Best, Stoney Stone, Louise and Joseph Simone, Ken Sklute, Peter Sorenson, Jane Conner Ziser, Judy Host, Lou Freeman, Monte Zucker, Hadi Doucette, and Lisa Jane Murphey.

How encouraging it has been to learn from so many amazing and talented people who have influenced my understanding and continue to educate me: Julieanne Kost, Katrin Eismann, Ben Willmore, Jack Davis, Bruce Fraser, Jeff Schewe, Russell Brown, Andrew Rodney, Deke McClelland, Scott Kelby, Jan Kabili, Martin Evening, Jim DeVitale, Don Emmerich, Seth Resnick, Jack Reznicki, Ed Pierce, John Paul Caponigro, Stephen Johnson, Kevin Ames, and so many more who I may have inadvertently omitted.

Thanks to my friends at Software-Cinema—Linda Collins, Gary Burns, David Burns, and staff, who always encourage me to produce my educational DVDs.

Thank you to the many helpful friends from the Professional Photographers of America and National Association of Photoshop Professionals. Also, a special thanks to Adobe Systems, and the many experts who are always willing to share.

Most respectfully, I want to thank Darryl Cohen for his exceptional guidance and prescience.

Thanks to the most important people in my life: my two wonderful and supportive children, Ian Vaughn Tapp and Ivey Raine Tapp, who fill my life with much love and who I am so very proud of. Thanks, also, to my loving sister Nancy Hendrix, and especially to my two amazing parents, Max and Mildred Tapp, who have always given me encouragement and have been my greatest support in my life and career. Thank you, Mom and Dad, for all your love and support.

Most importantly, I want to thank God for the multitude of love and blessings.

The Search for Consistent Color

Color management allows users to capture or scan, process, and output digital files in order to obtain predictable results with devices that are calibrated and profiled correctly. Adopting a color management system ensures that colors will consistently appear the way you want and expect them to. In this chapter, we'll take a quick look at the history of color management and how it is used today.

Contents

Chapter 1

A Brief History of Color Management

While we can't pinpoint when color management started, we can imagine that artists have always wanted some way of creating consistent color results. Humankind has been managing color for thousands of years, but not in the technological way we think of it today.

Early artists colored cave paintings and pottery using a wide variety of pigments from nature. Over the course of history, those pigments evolved from ground earth and clay to the many pigments and dyes that we use today. I'm sure that even these early artists strived to use the right colors to express themselves. Like today's artists, they probably found it important to mix colors that would match what they envisioned and to be able to match an existing color in the middle of a project. Hence color management was born. However, I'm sure that they didn't call their artistic efforts "color management" and that they had no idea of where it would go.

Let's fast-forward a bit from the cave-painting days. Sir Isaac Newton did the first scientific study of color in the 1600s, observing that light passed through a prism split into various colors. Based on this observation, he theorized that white light actually contained all colors. He developed the Newton color circle, placing the additive primary colors of light (red, green, and blue) around the circumference of a wheel and thus creating a tool that could predict the results of mixing certain colors or setting them next to each other.

In the early 1800s, a scientist and physician named Thomas Young proposed that human color perception depended on sensors in the human eye

that were sensitive to the three additive colors: red, green, and blue. The brain combined the color information to make one coherent color image (similar, in some ways, to the red, green, and blue sensors in today's digital cameras).

This conceptualization of human color perception was first put to photographic use in the late 1800s, attributed to the physicist James Maxwell. Maxwell created the first color photograph by shooting three images, each with a different primary color filter over black-and-white film. When these images were projected with the same three filters and aligned, they formed a color photograph.

In 1931, the Commission Internationale de l'Eclairage (CIE, or International Commission on Illumination in English) took up the task of standardizing the mathematical definition of color. They determined that spectral colors could be mapped using two coordinates (x and y) for chromaticity, resulting in a horseshoe-shaped curve. This is still the primary model in use today to explain the range of perceptual color.

Obviously, quantifying and predicting color has been the subject of human inquiry for a while. Today's concern over color management is just the continuation of that quest.

Image © Eddie Tapp

Color Management Today

By taking advantage of technological advances in equipment, software, and operating systems, you can easily create a color-managed workflow. Technological tools make it easier than ever to apply a consistent color management system, and as we'll discover, consistency is the key.

Color management as we know it today originated in the printing industry, where development of the photo-reproductive technique and the printing press introduced processes that have been carried forward to the computer revolution of today.

Even in the early days of the printing press, managing color was crucial both for accurate reproduction and for cost reduction. Often relying on trial and error, press operators developed an instinct for how their particular machines behaved. As time went on, experts in the printing industry developed new techniques to assist in accurately predicting color.

Color management has gone through many changes over the past decade—from incorporating color spaces within digital cameras to allowing the proper algorithms from computer operating systems. The good news is that using the science of color management to obtain predictable results is becoming easier and easier. We can assert consistent control over the equipment, and more importantly, software and firmware can accurately and automatically funnel input color spaces into output or device color spaces.

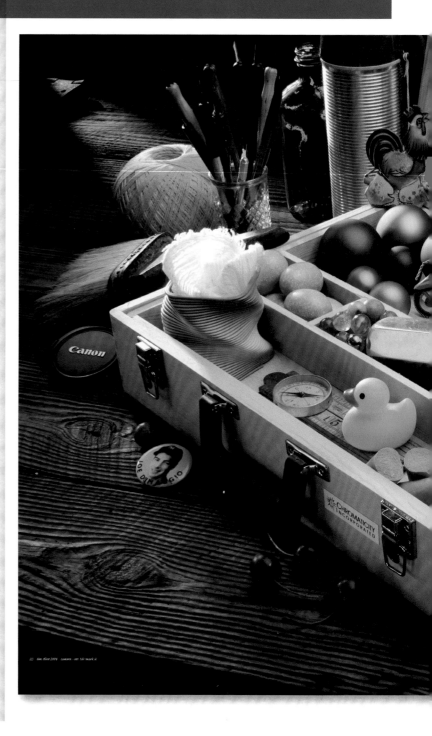

Today, almost all color reproduction is created and processed via computers. So when we speak of color management, we are usually referring to ICC color management. A great deal of color management is accomplished by using established profiles for specific devices, most notably ICC profiles. Made up of over 70 companies, including HP, Adobe, Microsoft, Kodak, Fuji, and many more, the ICC (International Color Consortium) is an impressive group of technical representatives from manufacturers and software developers dedicated to improving color management technology.

Although ICC color management is an evolving standard and is far from perfect, it is used a great deal and performs very well indeed for many users. The ability to use ICC profiles to manage color from one device to another has brought a level of consistency that allows a workflow to obtain predictable results from the very first try.

Profiles Create Common Language

Device-independent calibration is one of the reasons color management has become easier to control. When we calibrate a device today, we start with a standard setting for that device rather than tweaking the settings to emulate another device, whereas in years past, we would, for example, calibrate a monitor to simulate a print from our lab or ink-jet printer.

> Device-dependent (calibration based on human perception rather than the peculiarities of a given piece of hardware) calibration works fine for a closed loop workflow where all the devices that will be used are known quantities (but even then only temporarily because of drifting phosphors on CRT monitors).

Today, manufactures of digital cameras, scanners, and printers (as well as makers of profiling equipment, software developers, and creators of advanced device drivers) have for the most part added the necessary options to allow for proper color management.

However, even with the ease of today's technology, workarounds still have to be implemented in some workflows to compensate for older equipment, software, and operating systems that may not yield compatible results.

What should you do? Take the responsibility to understand the characteristics of the devices that you are using, including digital cameras, scanners, monitors, printers, and projectors. You can calibrate and use a device at a known set of specifications and learn how it yields consistent results. Based on this experience, you can predict the final results. It is then possible to manage an image file from one device to another with the added ability to see the proper pixel data (color and tone) on a monitor and get predictable results every time.

In the most basic sense, there are three stages of a color-managed workflow:

1. **Establish a working color space.**

2. **Calibrate and profile your devices.**

3. **Use the appropriate profile.**

As we'll see in Chapter 4, these stages can actually be part of a seamless or automatic workflow. In any case, the spine of a successful color-managed workflow is working with a color space and calibrated and profiled devices as well as having the means to convert the color space to an output device before printing.

Consistency is the key, as you will read many times in this book, of any workflow, whether it is color-managed or not. Predictability is what you must demand. Whether you like an image or not, if you can predict how it will look once printed, you can then take control to obtain the results you want, consistently.

Understanding Key Color Management Concepts

When working with color and color management, it is helpful to understand the concepts and terminology of color. This chapter will help you understand the concepts of a profile and a working space. Gaining a general sense of the language of color management will help you navigate your color workflow with confidence.

Contents

Chapter 2

Calibration Versus Profiling

In reality, calibrating and profiling is a partnership rather than a competition, but people frequently confuse these terms. Calibrating is like giving a device a fine tune-up, while profiling is describing the exact color gamut of the device in its already tuned-up condition.

Calibration refers to setting up a device in a centered state or known condition, where it can then yield the best performance within given parameters. For example, you might calibrate a device to a color temperature setting of 6500 degrees Kelvin and a gamma setting of 2.2 (don't worry, those settings will make sense after Chapter 4). Once you've established a few parameters, the tool to calibrate the monitor can position the color temperature and gamma for proper viewing during calibration.

Profiling is measuring the capabilities of a (calibrated) device and then saving this information in a file known as an ICC profile. The ICC profile is used as a color space that your file can be converted into in order to manage the color while you view an image on a properly calibrated display.

The term "profile" is also used to describe a combination of elements or characteristics. When using a film scanner, for instance, you can choose a profile of a specific film type such as Fuji or Kodak film, or even a look, such as a "portrait look" (less saturated) or "product look" (more saturated). These profiles are more specifically LUTs (lookup tables) that allow you to control the centering or color temperature of the scanner along with other properties such as gamma or contrast settings.

When shooting in the JPEG mode, a digital camera will allow you to set a matrix that could include a color space (such as sRGB or Adobe RGB), saturation, contrast, and even sharpness settings. This too is a type of "LUT" profile, where the color space's sRGB or Adobe RGB are actually a color space profile embedded in the file from the camera's firmware. RAW profiles are embedded during processing and not in the camera.

Device calibration can be achieved using sophisticated tools or software that is packaged with the device. For instance, an ink-jet printer might include a utility that allows you to establish print head alignment and nozzle cleaning for calibration. A monitor or display is best calibrated using a device known as a colorimeter. In either case, there is always a "proper" way to calibrate a device, given a type of workflow or objective.

We'll get to that in Chapter 4, but for now, understand that calibration of a device goes hand in hand with creating an ICC profile of the device in its calibrated state. If results suddenly become inconsistent in a workflow, recalibrating a device will bring back the consistency.

Device Profiles

Once you calibrate a device, you'll then want to create a profile that describes the device's range of color and tone in its calibrated state. These device profiles can communicate with other device profiles in a color-managed workflow to increase the consistency of results.

Output Profiles

An *output profile* is a characterization of the range of colors that a specific printing device and paper type reproduces. To create an output profile, a variety of color patches must be printed and measured with a device known as a spectrophotometer. The next step is to enter the data from the patches into a software-profiling application to create an ICC profile. The software compares the known color values of the patches sent to the printer to the actual colors that were read with the spectrophotometer and, using the data from that comparison, creates an ICC profile.

The Xrite Pulse Elite, a color spectrophotometer

Monitor Profiles

A *monitor profile* is created during the calibration process with a device known as a colorimeter, which compares the values and colors that it reads to a known set of values and colors. The monitor profile (also known as the *system profile*) will serve as a viewing filter, allowing you to see your image data more accurately. The dynamic range, or contrast levels, of the monitor is limited by the maximum brightness that it has. Newer LCD monitors are usually brighter than older CRT monitors, and are thus capable of a wider dynamic range.

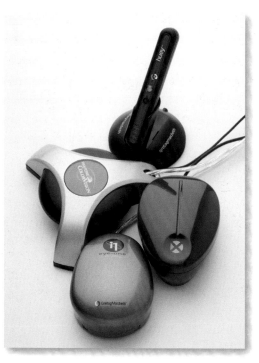

Colorimeters

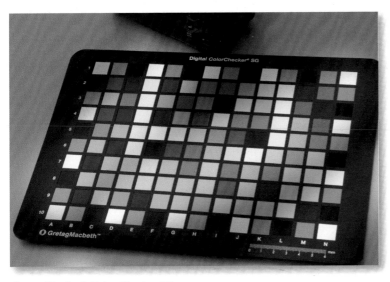

GretagMacbeth Color Checker SG

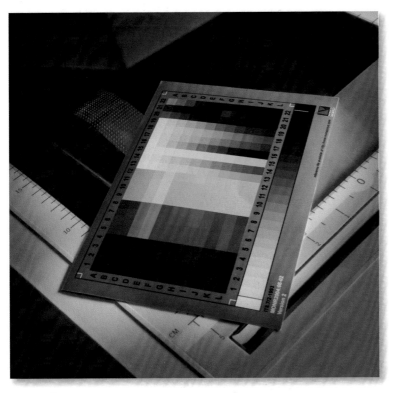

An IT-8 chart

Input Profiles

Because scanners and digital cameras don't have a fixed gamut (see the next section, "Color Space"), input profiles for these devices are a little bit different than output and monitor profiles.

Input profiles do, however, have a fixed dynamic range. So an *input profile* can characterize a device, but it is limited to the target that you use to create the profile. With scanners, this limitation is usually not a problem because you can make a target with a dynamic range and gamut of colors as good as any image that you would scan. A digital camera, on the other hand, captures colors in the real world much better than any target that could be made. The camera-profiling software has to extrapolate the colors that are outside the target's gamut. For this reason, profiling digital cameras is limited.

Matrix and LUT Profiles

Profiles themselves can be matrix-based or LUT (lookup table)-based, both of which include the white point of the device. But matrix-based profiles are very small, while LUT profiles are much larger and more complex. A *matrix profile* is a mathematical model made up of the three primary colorants of the device and some simple tonal curves, referred to as a 3 x 3 matrix. A *LUT-based profile* contains much more information, consisting of a table of numbers that allows you to find an input value and its corresponding output value. Matrix-based profiles are used for simpler devices, such as scanners and monitors, while LUT-based profiles are used for more complex devices, such as printers.

There are many different color spaces available, and most of them are matrix-based. The advantages of a matrix-based profile are conversion speed and the ability to convert back and forth.

PCS Source and Destination

Profiles are usually used in pairs. Generally, you will go from a source profile to a destination profile. In order to use a profile to convert from one device to another, we need to go through an intermediate color space known as the profile connection space (PCS), which works like a translator, converting from one color space to another. This conversion can be from RGB to RGB, CMYK to CMYK, RGB to CMYK, and others.

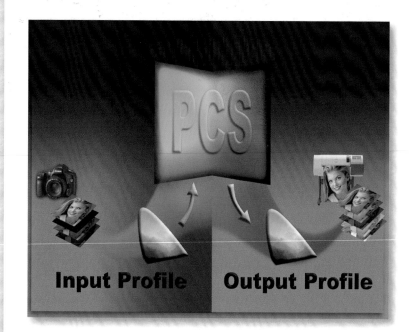

Input Profile **Output Profile**

THE COLOR MANAGEMENT MODULE (CMM)

The last component of a color management system is the Color Management Module (CMM), which is the engine under the hood that does all the calculations. The CMM is usually part of the operating system, but there are third-party CMMs available. The default CMMs for both Windows and Mac operating systems were developed by the same company, Heidelberg, and should perform the same on both platforms. Photoshop has its own CMM, named Adobe (ACE), that is the default within the Adobe suite of applications and can be changed if needed for a particular workflow that is directed by equipment and software interface specifics. In most cases, you do not have to set your CMM; it will use the default.

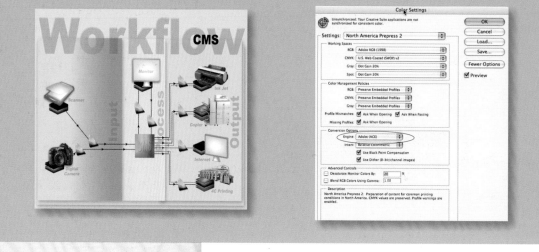

A color space model shows the color gamut of a given device or image. Viewing the graphs allows you to compare profiles and images. It is relatively easy to see which colors are within the gamut of a color space and which colors are outside the gamut.

Color Space

A representation of Adobe RGB 98 color space, which is considerably larger than the sRGB

Simply put, the gamut is the range of colors that a specific device can see, display, or output. The larger the gamut, the more colors.

A 3-D representation of the sRGB color space

A gamut can be displayed as a two- or three-dimensional object. A gamut represented as a 2-D figure is easy to read and is a good way to get an idea of its size. However, color is actually a three-dimensional space and is usually displayed as LAB values, with a light/dark axis (L), a red/green axis (A), and a yellow/blue axis (B).

The LAB color space consists of the range of colors that the human eye can see and has a very large gamut. There are three axes. The L axis represents the brightness, with pure white on the top and pure black on the bottom. The A axis ranges from −A (green) and +A (red). The B axis ranges from −B (blue) to +B (yellow). The resulting 3-D graph shows the available gamut. However, the devices that we use for digital imaging and photography are much more limited in their color gamut, and each device's gamut is unique.

A 2-D model of the smaller gamut of sRGB inside the larger Adobe 98

A 3-D model of the smaller gamut of sRGB inside the larger Adobe 98

The illustrations on this page show the visualization of a variety of gamuts of both color spaces and output color devices.

Device-Dependent Color Spaces

Both RGB and CMYK are device-specific color modes: for a given set of CMYK or RGB numbers, the colors you get will vary from device to device. If, for example, you have two identical printers and you send the exact same file to each, the printed images will not match each other exactly, even though the same RGB or CMYK values were sent to both devices. If the printers are from different manufacturers, these differences will be even greater. With an ICC profile, you can make these different devices match each other in terms of final product, but the actual RGB or CMYK values will be different.

Device-Independent Color Spaces

Independent color spaces are defined regardless of device. For instance, CIE XYZ was developed by the CIE (Commission Internationale de l'Eclairage) as a mathematical model to describe how the average person sees color. Since that time, other variations on this color space have been developed, the most common being CIE L*a*b* (usually abbreviated as LAB).

If you wish, images can be edited in this color space with programs such as Photoshop. However, LAB is a very unintuitive color space to work with and edit images in. For the most part, it is used as a connection space for translating colors—for instance, when converting from one space to another, such as from RGB to CMYK. LAB understands the relationship between itself and each dependent color space. Because LAB is close to a linear and uniform color space, it does a very good job as a translator.

A 3-D model of the standard CMYK profile in Photoshop, which is a SWOP printing press and is a smaller gamut than that of an ink-jet printer

The orange is the Abobe RGB 98 color space while the blue is an ink-jet printer; Adobe space encompasses most of the printer space

The blue represents the gamut of an ink-jet printer compared to the gamut of sRGB color space; notice that there are quite a few colors in sRGB that are outside the gamut of the printer

A 2-D model of the standard CMYK profile in Photoshop, which is a SWOP printing press that is a smaller gamut than that of an ink-jet printer

The bright green in this image represents the colors of a printing press that are out of gamut from the working space of Adobe RGB 98

The bright green in this image represents the colors of sRGB that are out of gamut from the working space of the image, which is Adobe RGB 98

Intermediate Color Space (Working Space)

In addition to input, monitor, and output profiles, we also have working color space profiles. Until Photoshop 5 came along, we really didn't have to deal with color spaces very much. (In previous versions of Photoshop, the working space was usually the monitor profile.)

With Photoshop 5, Adobe introduced working spaces, which were selectable in the color preferences. The two main advantages to this are:

- **The image resides in its own color space and is not limited to the profile of the monitor.**

- **The image won't change from workstation to workstation as long as the color settings are set up to use the same working space.**

A wide variety of color spaces are available, but the two most common RGB working spaces that photographers use are sRGB and Adobe RGB 98. Of the two, sRGB has a smaller gamut, while Adobe RGB has a considerably larger gamut. (There's an even larger color space that you can use: Wide Gamut RGB.)

You might think that using the widest color space is best. However, as we'll see in the next section, using a wide color space can cause problems later on when you are trying to convert the image for output.

Rendering Intents

As you've learned, different devices have different size gamuts. When you convert from one color space to another, the colors and tones need to be changed to fit into the new color space. The rendering intent is the strategy for resolving the differences in color space.

Rendering intents determine how the color of one device converts to another device. Depending on the color and tonality in the two different color spaces, the differences can range from minimal to fairly dramatic. When converting from one space, such as RGB, to another, such as CMYK, we go though the PCS (discussed in "PCS Source and Destination," earlier in this chapter). There are four different rendering intents that ICC profiles may have for resolving color differences: perceptual, saturation, relative colorimetric, and absolute colorimetric.

The images here illustrate the differences among the four different rendering intents. The effects of the different intents have been exaggerated so that they are easier to distinguish visually. Even with the exaggerated colors, it is still sometimes difficult to see the subtle differences.

Original image

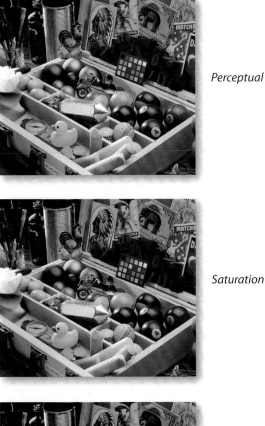

Perceptual

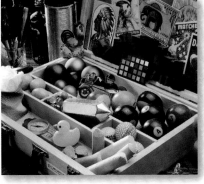

Saturation

Relative colorimetric

Absolute colorimetric

Perceptual

This intent (sometimes referred to as photographic) tries to preserve the overall color appearance by changing the colors of the source image to fit into the destination space. It sacrifices accuracy to produce a more visually pleasing image. This intent is very useful when the source has a wide gamut and the destination has a small gamut.

Saturation

This intent tries to produce the most vibrant color by pushing the color of the source image out as far into the destination space as possible. It is not used much by photographers but is often used for business graphics to achieve bold color in presentations.

Relative colorimetric

This intent is used when color accuracy is the most important concern and is the default rendering intent in the more recent versions of Photoshop. It works very well when the source and destination profiles have similar gamuts. If the gamuts of two devices are too different from one another, the more saturated color may be clipped or minimized.

Absolute colorimetric

This intent is usually used for proofing when trying to simulate one device on another. It is similar to relative colorimetric, except all the color adjustments are based on the white point. Unlike relative colorimetric, absolute colorimetric shows the white of the source profile. In some cases, this intent can create an undesirable color cast if used as a default.

Establishing a Color Management–Friendly Workflow

Before you can implement effective color management, you need an efficient workflow environment in which to practice your color management strategies. This chapter describes how to establish a sound digital workflow, broken down into three stages: input, process, and output. Sound color management doesn't just happen. To get the results that you demand, you must first generate an adaptable framework during these stages.

Contents

Chapter 3

Input Stage

The ability to implement consistency has been enhanced by the advent of color management, but it's still a challenge. Within the three stages of a digital workflow, the most challenging stage in which to maintain consistency is the input stage because the types of input vary so widely.

Input can come from three main sources: scanners, digital cameras, or digital files supplied by someone else. Each type of input brings its own challenges with regard to maintaining consistency.

Scanned Input

Scanner input variation arises from the different substrates you might want to scan. Transparency film, negative film, prints, and flat art comprise most scanning workflows, and each has different parameters to consider.

Whether you're using drum scanners, dedicated film scanners, or flatbed scanners, scanning technology has improved dramatically in recent years, allowing for faster and easier scanning workflows, with better color and tonality and the incorporation of color management. These advancements are mostly due to improvements in software and driver interfaces along with higher-quality sensors.

Resolution, color, tonality highlight and shadow, sharpening, bit depth level, dust, noise, and, of course, color management will all affect your scanning input. Most of these settings can be adjusted within the software or driver interface. Another option is to adjust and correct scans from within Photoshop.

Image © Eddie Tapp • Phil Ehart • Kansas

most scanner driver interface options show resolution settings in a pull-down menu, and the native resolutions are usually bold or underlined.

Choosing scanning resolution

A good starting point in achieving superb scans is knowing your scanner's *optical resolution*. If a scanner's optical resolution is 1600 ppi (pixels per inch), you can multiply or divide that by a factor of two to achieve *native resolution*. Take an optical resolution of 1600, divide by two, and scan at 800. Divide by four and scan at 400. Multiply by two and scan at 3200. All of these are native resolution settings, which are the result of the scanner quickly dividing or multiplying its optical resolution to yield optimum results. If you set this scanner to scan at 1250 ppi, it will scan in this nonnative condition, but this setting will create two critical workflow bottlenecks:

- **The scanner speed will slow down because it must interpolate the data.**

- **The nonnative scan will yield a lower-quality pixel integrity.**

Scan for the final output (print size and resolution) whenever possible. It is best to scan at the native resolution nearest the resolution or file size that you need. For instance, if you are scanning to produce an 8 x 10 print on a device that requires 250 ppi (pixels per inch) resolution, you will produce a file nearly 14MB in size. To produce a 16 x 20 print at a resolution of 200 ppi, the file size will be close to 37MB. (Both of these measurements are in RGB 8-bit). In Photoshop, under File → New, you can type in inch and resolution

settings and learn the file size you need for output. In the scanner interface, choose the resolution that scans close to your target file size, preferably using native scanner resolution. Once the scan is complete, in Photoshop, using Image → Image Size, you can resize the image by resampling to the exact dimensions and resolution, or you can even use the Crop tool with the settings in the Options bar.

> If you are scanning for multiple uses, it is best to scan to the largest size and then resample the image to make it smaller in Photoshop.

Leveraging the scanner's software

Some scanners include software that is extremely limited, while others offer full-featured software, allowing you to scan with many excellent tools. Some software gives you the option to scan in different modes, ranging from totally automatic to expert manual. If your scanner's software is not adequate for accurately controlling the scanner, you have the option of either purchasing a scanner that allows more control or acquiring third-party software. Good software properly used will allow you to preview a scan on your monitor with accurate color and tonality. You might have the ability to improve the image by adjusting the highlight and shadow, color, and tonality. If your scanning software does not allow for accurate color or is limited in controls, it may be best to scan your images with the default settings and then make adjustments in Photoshop. Be careful with default settings that are automatic, because in most cases the automatic settings can lose detail in both

✓ RGB
RGB 16 bit
Grayscale
Grayscale 16 bit
Lineart
CMYK

--- Standard ---
CMYK dark
CMYK dark saturated
CMYK saturated
CMYK standard
RGB dark
RGB dark saturated
• RGB saturated
RGB standard
--- Standard Negative ---
Agfa Optima II 100
Agfa Optima II 200
Agfa Optima II 400
Fuji NPH 400
Fuji Superia 200
Fuji Superia 400
Kodak Gold 200
Kodak GPX 160
Kodak Portra 160 NC
Kodak Portra 160 VC
Kodak Portra 400 NC
Kodak Portra 400 VC
Kodak Pro 400
Kodak VPS III 160
Konica Professional 160
Konica Professional 400
Konica VX 100
Konica VX 400
Negative CMYK saturated
Negative CMYK standard
Negative RGB saturated
Negative RGB standard
--- User defined ---

Image © Eddie Tapp / Kansas

the highlights and shadows. This is the case if you open a scan in Photoshop, because the scanning interface does not use the monitor profile for viewing, which Photoshop does automatically.

Most scanning software includes advanced settings or preferences, including color management settings for input, monitor, and RGB and CMYK ICC profiles. Using custom or factory input profiles for the scanner will assist you in matching the image that you are scanning.

However, scanning negative film may require a lookup table (LUT) of predetermined characteristics because the film base, usually orange in color, must be compensated for during scanning. While using a custom input ICC profile for negative film is a wonderful solution, these profiles are very difficult to create and are not easy to come by. The next best solution is to use a negative LUT for a particular type of film.

Starting with high bit depth

Scanners have a bit-depth level of either 8 or 16 bits per channel. More bits means more tonal information. An 8-bit image has 256 tones per channel, and a 16-bit file has 65,536 tones per channel. A 16-bit scan yields a fantastic amount of tonal information, which is useful for editing without degrading the image. When you apply a profile to a scan, it is better to start with a high-bit scan. Also, if you plan to do some major editing in image-editing software such as Photoshop, the extra tonal information will help a great deal in preventing posterization or banding.

Avoiding dust and noise

Start with the best image possible by cleaning your glass, slides, negatives, and flat art carefully before scanning, using only recommended methods from the scanner manufacturer. Higher-end scanners, especially at greater resolutions, show more dust than less expensive scanners at lower resolutions. Dust is always a problem, especially with flatbed or film scanners. Drum scanners minimize this problem if the source image is oil mounted by applying a liquid film over the actual film. You can also oil mount film on flatbed scanners. Some scanners use Digital ICE, an amazing software technology that will minimize dust when scanning. However, when you use such an option, the scanner will take much longer to scan, and the final result may not be as sharp as it would be otherwise.

Noise from a scan can be caused by high ISO film speeds, underexposure, pushing film speed during processing, and by heat in the scanning device itself. With the exception of drum scanners, scanners introduce noise in the shadow areas of transparencies because the dynamic range of the scanner is smaller than the dynamic range of the film. Transparency film can have a density range of up to 4.0, while the density range of most non-drum scanners is around 2.9, thus creating noise in the dark shadow regions. However, drum scanners have the ability to pull detail from shadow regions of transparencies with little or no noise.

Scanning halftones

When scanning a page from a magazine, book, or anything that has halftone dots, a descreening option in the scanner interface will reduce this pattern but result in a softer image.

Images © Lou Freeman Photography

In the production-techniques-oriented books in this series, I will cover a scanner dust-spotting technique that uses Photoshop's History brush to minimize dust spots very quickly, leaving a high level of sharpness and pixel quality. I'll also discuss other techniques in Photoshop to minimize digital noise.

Sharpening is best kept to the last step in the process before outputting the image, and unless you're scanning for direct printing (bypassing other processing options in Photoshop), I recommend scanning with no or little sharpening settings from the scanner, thus ensuring expanded pixel data.

Scanners will be around for a long time to come because we not only have prints and flat art to scan, but billions of negatives, transparencies, and artifacts that are stored for the future using scanning technology.

Input from Digital Cameras

Digital capture has brought enthusiasm to the digital workflow because it allows you to create the image in the camera, process it in Photoshop, and then send the file to the lab or digital printer within minutes, if necessary. It is also possible to capture an image and send the file to a printer directly (as many event photographers do on-site), and there is even the option of wirelessly transferring images to your computer as you're shooting. When a digital camera is providing input, you're faced with keeping things such as white balance and exposure consistent under

changing lighting and environmental conditions.

Digital camera input and resolution

Compared to a scanning workflow, in which you can scan to the size of the file (or the resolution) needed for a particular output, digital camera resolution is for the most part determined by the camera's available megapixels. Mega (meaning one million) pixels (meaning a light-sensitive photon) are set to a particular size during capture. So a 12-megapixel camera yields 12 million tiny photons on a sensor that becomes what we referred to in a film workflow as the "latent image" after the exposure.

Once you process a 12-megapixel file, the converstion to RGB will cause the file to become three times larger, thus yielding a 36MB RGB file.

In your workflow, this 36MB file would be considered the original file resolution. You can resample the image with Photoshop or a third-party resampling software/plug-in to make it larger or smaller. If you're working with RAW files, you can resample from Adobe Camera RAW or another RAW software interface. At this point in your workflow, the most important factors for resolution are proper white balancing and proper exposure of the original capture because a healthy original file can yield bigger and better quality output. It's more forgiving.

When you're shooting in JPEG (or TIFF) format, the camera processes the image as an 8-bit file. When shooting in RAW format, you can process the file into an 8-bit or 16-bit image along with controls for

RAW

Name _MG_1069.CR2
Kind Camera Raw
Size 11.7 MB on disk

TIFF

Name _MG_1069.tif
Kind Adobe
 Photoshop TIFF
 file
Size 36.5 MB on disk

JPEG

Name _MG_1069.jpg
Kind Adobe
 Photoshop JPEG
 file
Size 5.8 MB on disk

DIGITAL IMAGE SENSORS (CMOS VERSUS CCD)

There are two types of digital image sensors: CMOS (Complementary Metal Oxide Semiconductor) and CCD (Charged-Coupled Device). The majority of SLR digital cameras today employ CCD sensors. However, as the technology of CMOS sensors improves, digital cameras will use these new chips. Some manufacturers are already using CMOS sensors in their digital cameras, and the quality is excellent. The primary practical difference is that a CCD chip may require more of a controlled temperature and more electrical power, thus requiring more battery use, but it yields a sharper file initially. The CMOS sensor requires less battery power, has a broader range of temperature sensitivity at a given ISO setting, is less contrasty, and produces less digital noise at higher ISO settings.

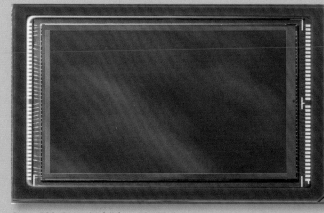

Canon EOS 1Ds Mark II full-frame CMOS chip

Image © Eddie Tapp

white balance, color, sharpness, contrast, brightness, exposure, and more to create a healthy original file.

Think of shooting JPEG as creating a color transparency in which proper exposure is critical, whereas shooting RAW can be compared to shooting a color negative— exposure is certainly critical, but the exposure controls in the RAW process have a greater latitude.

> One of the main challenges of digital capture is getting the color and exposure right from the start, which will not only save time in production, but will ensure the very best output quality.

Establishing white balance

Specialized imaging devices allow you to capture a light spectrum that includes everything from X-rays to infrared light, but we're interested only in the part of

the spectrum that is visible to the human eye. Visible light has a color temperature that is measured in degrees Kelvin. The higher the number the bluer the image, while the lower the color temperature, the yellower the image. We refer to visible-light color temperatures as daylight, tungsten, fluorescent, and so on, each having a different Kelvin degree temperature. Daylight is considered to be approximately 6500K and tungsten light 3200K. However, the color temperature of daylight varies a great deal depending on the time of day, season, and altitude. Our eyes adjust to these changes, but cameras take things a little more literally. Because these variations will change color perception in general, white balancing will become an important part of your workflow.

There are three primary options for white-balancing digital cameras:

Auto

Although auto works extremely well in many conditions, it can potentially generate a different color temperature from one image to another, which is important to keep in mind when you need to implement consistency. While an image may look great by itself, it may require individual adjustments to look consistent with other images if it is going to appear in a book, presentation, or montage.

Preset

The presets for white balancing that come with most digital cameras let you choose a specific color temperature, such as daylight, tungsten, shade, fluorescent, cloudy, flash, or even a dial-in. Using a preset white balance may allow more consistent color

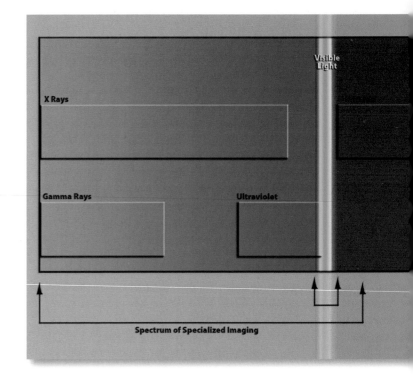

Radio Waves

Graphic © Eddie Tapp

Images © Eddie Tapp / Model: Teri Ferguson

among images in a given lighting environment, and if you need to make adjustments, they can easily be applied to an entire set of images.

Custom

Custom white balancing allows the camera to balance the color temperature more accurately, taking in not only the primary light source itself but surrounding elements that may influence the color temperature (such as green grass, red brick, or blue sky). Custom will also white balance the camera to a light source other than one of the presets. Tools for white balancing a digital camera include a reflective readingsuch as a digital gray card, white card, or a non-color bias (neutral) reference that you can use to create an exposure of the reference (gray card) in your scene, or an incident reading, such as the ExpoDisc that fits to the front of the lens, allowing you to create an exposure of the light coming toward your subject.

Regardless, once you have your white balance exposure, there are two provisions to set on your camera. First, set the camera's white balance function icon to "custom" (check your reference manual if you need to), and second, in the camera menu, select Custom White Balancing. This will allow you to select an image to use as the source. Select the image, and then select Set or OK. You are now shooting with a custom white balance since the camera has balanced the color temperature to your specific lighting conditions.

Use a custom white balance whenever possible, especially when

photographing a series of images in an environment that has fast-changing lighting conditions. Learn to quickly switch your white balance to either a preset or saved custom setting to keep your color as consistent as possible.

Exposure

Exposure control is perhaps the single most important factor to most of us when using a digital camera, and it is certainly the best way to ensure detail in both the shadow and highlight regions, not to mention the best way for color management to work seamlessly through the process.

Some people can look at any scene, consider all the elements, and determine the correct exposure with the blink of an eye; experience is the best teacher when it comes to getting a proper exposure. In the meantime, you'll need to employ the tools available—in-camera metering, the preview histogram, Exposure Mode, exposure compensation, and custom camera functions, along with a professional handheld exposure meter— to help you achieve proper exposure.

Once an area is grossly overexposed using a digital camera, the only means to regain detail is to rebuild the texture using advanced rebuild techniques that we'll cover in the Advanced Production Techniques book.

Become familiar with the various shooting modes for your camera, such as Program (P), Shutter-Priority (Tv), Aperture-Priority (Av), Manual (M), and (B) Bulb, and meet the challenge of becoming proficient with your exposure.

RAW WORKFLOWS

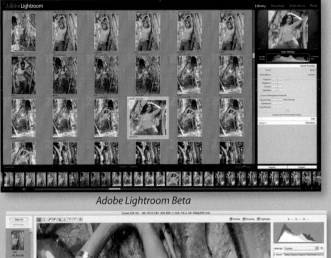

Adobe Lightroom Beta

Adobe Camera RAW

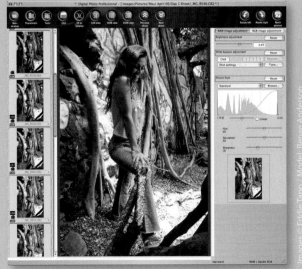

Digital Photo Professional - Canon

Once again, when it comes to exposure, shooting RAW has many wonderful advantages in today's high-quality digital workflows. RAW allows you to quickly change exposure compensation without sacrificing pixel quality. All digital camera manufactures have software for processing their proprietary RAW file formats, such as Digital Photo Professional from Canon, Nikon Capture Editor from Nikon, and Capture 1 by Phase One, all of which give you the ability to maintain the highest possible pixel quality. There are also other third-party software options for processing RAW files, such as Adobe Camera Raw, Adobe Lightroom, Bibble Pro, and Aperture, that have powerful features for today's digital workflows. This software works with file types such as JPEG and TIFF for individual or batch editing, renaming, and processing. However, these programs are best at processing RAW files, especially in large operations that may have large numbers of RAW files from various different cameras. Having the ability to process and manage all of these files with one application greatly increases productivity.

(Compared to shooting with the much smaller JPEG format, a RAW workflow requires a healthy amount of manageable hard drive space, which we will discuss at the end of this chapter.)

Images © Eddie Tapp / Model: Renae Anderson

WHEN TO SHOOT JPEG?

JPEG workflows are best suited for event photography, photojournalism, public relations, some government agency work, and other types of high-volume workflows in which images need to be uploaded or wirelessly

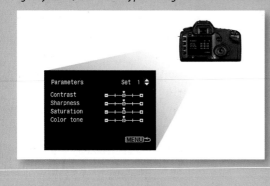

transfered quickly to a printer or via the Internet. When shooting in the JPEG format, you have color space options, such as sRGB or Adobe RGB, which will help create and customize a picture style or "look," that include settings for saturation, contrast, color tone, sharpness, and even filtering or toning effect. These "looks" can represent settings for portrait, product, landscape, or even monochrome.

Other considerations with digital cameras

Keeping the digital camera sensor free of dust is extremely important and should become part of your maintenance routine. When you change lenses in the field, such as in a building where there are lots of dust particles, dust can invade the inside of the camera body and find a home on top of the sensor. The dust particles will appear as spots on your image files, usually at the same location on each image, causing a considerable amount of additional retouching time. Some photographers will have several cameras with different lenses, never changing the lens so as to keep sensors free from these intruding particles. Camera stores offer the necessary tools to keep your sensors clean, and some offer a professional sensor-cleaning service.

Keep a close eye out for online firmware updates from your camera manufacturer. These updates expand camera capabilities and offer improvements for certain camera functions. Some camera manufacturers,

such as Nikon, require that you send the camera back to the manufacturer for a firmware upgrade; others allow you to simply download a small text file, transfer it to your camera's flash card or microdrive, place the card in your camera, and use the menu on your camera to quickly update the firmware. (In some cases, you can hook up your camera to your computer for update transfers.) Be very careful that the camera does not turn off during the firmware update, or you could corrupt the chip in the camera, which would then require sending the camera back to the manufacturer to be fixed.

Image © Eddie Tapp

Input from Supplied Files

Supplied digital files are files that come into your workflow from other photographers or clients who need your specialized processing services, such as retouching, enhancements, further processing, or printing. Your input comes from a variety of customers with a variety of digital equipment, operating systems, and methods of image processing. These files can be and usually are in many different formats and conditions, and some may require advanced techniques in color correction, image manipulation, and proper use of a color space for color management (see Chapter 4).

As this chart indicates, once you transfer your files (RAW or JPEG) to your workstation or computer, the files can then be viewed in what I call the "Sales Room," where you will make master edits. These edits become your Selected Files and are then saved in your archival or backup system. Also, after the Master Edit, you can then print proofs or upload images to a website for viewing and ordering.

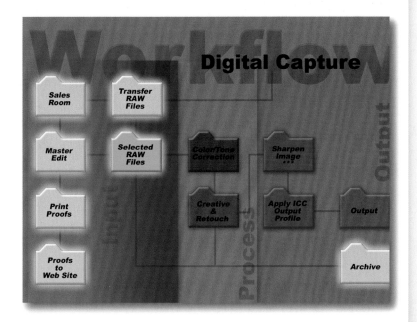

Process Stage

One of the greatest mentors in my career was Ansel Adams. He once stated that half the image is created in the camera, and the other half in the darkroom. In the digital age, the darkroom would be the process stage. The concept is the same, and refinement is the key.

Even though it is certainly possible to go directly from capture to print (input to output), bypassing this stage, the process stage is the one stage that allows refinements: cropping, retouching, image enhancements, and advanced image manipulation. Adobe Photoshop is the primary tool for this stage, but you can make color, tone, and cropping refinements with other tools, including any RAW-processing applications if you have a RAW workflow.

The very first step in the process stage is to establish overall color and tonal corrections. This is where your monitor's calibration is most critical. Next is the enhancement step to remove any unwanted spots or to perform minor retouching and cropping before moving on to creative or advanced image enhancements. (These enhanced images should be archived with the selected RAW or original files.)

I will cover color correction techniques step by step in the Controlling Color and Tone in Photoshop book in this series.

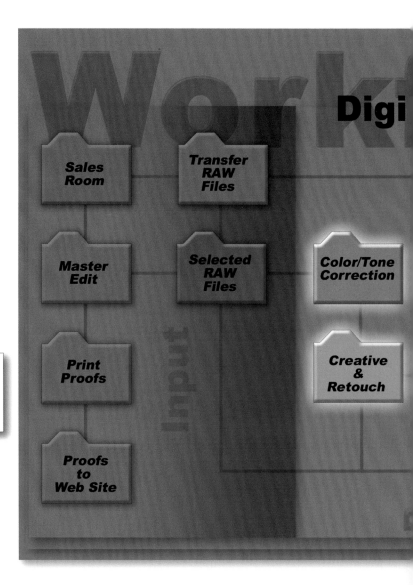

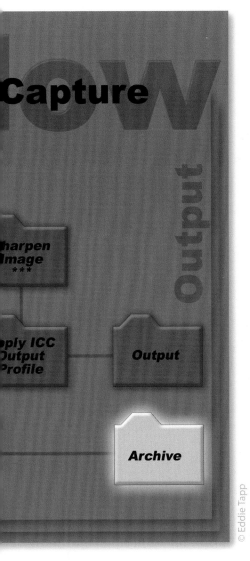

Process Refinement

Refinement is a critical part of making a successful image. It's what makes your work different from others'. For instance, let's consider a typical product shot. In the input stage, you set up the lights and then refine the lighting of the product and background for the desired effect. Similarly, in the process stage, you use various techniques, from color corrections to creative enhancements, to refine your image and make it your own.

It's helpful to divide the process stage according to the type of file you're working with: RAW, JPEG, or TIFF.

In a RAW workflow, establishing color and tone correction is relatively quick and easy because RAW yields a higher-quality file than other workflows. You can take an entire series of images that need the same correction and automatically apply it to all of the images by using any RAW image-processing application. Once you have processed the RAW files to the desired format, such as TIFF or JPEG, you can move to the creative, retouching stage.

In a JPEG or TIFF workflow, color and tone correction are the first step. If you have a series of images that all need the same correction, you can record an action in Photoshop and then automate the action to batch process all of the selected images before moving to the creative and retouching stage. Applications such as Aperture and Lightroom let you apply changes to all images, just as if you were working with RAW.

With either workflow, once you have established the color and tone, you can then move into the fun part of the process—creating the second half of the image and playing in Photoshop. Well, "play" might not be quite the right word, but it is fun to create enhancements, image montages, and have creative control. Naturally, this stage is when learning different techniques in Photoshop is most important. Other tasks you perform during the process stage might include assembling panoramas, designing albums, applying creative filter effects, creating image mattings, performing advanced retouching, and using actions to perform numerous image enhancements (more about this in the *Creative Enhancement Techniques* book in this series).

Processing Equipment

Your processing equipment consists of your computer workstation, your monitor, and the appropriate imaging software. Your workstation should have an ample amount of RAM and enough hard drive space to manage the files you process.

In this workflow chart of a directory structure, notice how the Local Computer will access the files to process from a server. In this type of workflow, all the image files reside on a server and the workstation will open, process, and save these files back to the server. With this type of workflow pattern, the Local Computer needs adequate RAM, the server needs enough hard drive space to store the files, and most importantly, the network needs to be high-speed.

Image © Eddie Tapp

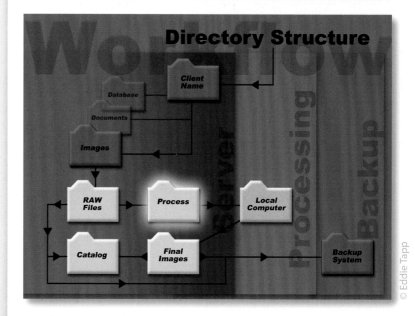

© Eddie Tapp

A properly calibrated and profiled monitor is the most important tool in the process stage, especially with regard to color management. If professional imaging is your livelihood, then I can't say enough about the importance of having a high-quality monitor that is able to show accurate color and tonal gradation from shadow to highlight. Without a proper monitor, when making color and tonal adjustments, you may remove critical pixel data from the file. This loss of data may then require advanced correction, which in most cases would not be as complete as it would be if the original data were still there.

Whether you need to create a simple adjustment or use an advanced technique, the process stage is where your creative energy can flow in Photoshop or a number of other applications, such as Painter, Aperture, Nikon Capture, Extensis Portfolio, iPhoto, and manufacturers' proprietary RAW-processing software. In later books in this series, I will cover many step-by-step processing techniques for color and tone correction, production, and creative and advanced controls using Adobe Photoshop.

Output Stage

Output is perhaps the easiest stage with regard to maintaining consistency. The challenge is to calibrate and profile your devices and maintain them. The ultimate goal of any digital workflow is the final product. You want to make sure that the image is printed or electronically displayed correctly.

Initially, calibrating some output devices may require a fair amount of work, but once calibration and profiling are established, they're easy to maintain. You may be outputting to an ink-jet printer, a dye sub, a photographic lab, a toner-based color copier, or a printing press. Or you may be outputting to the Web.

Preparing a File for Output

Regardless of the final destination, there are three areas of transition that your file may need to go through during the output phase: resolution, sharpening, and color space conversion. These tasks can be performed manually in Photoshop or automatically within a driver or software known as a RIP (Raster Image Processor). (Rick will discuss RIPs in detail in Chapter 5.)

Resolution

Take, for example, a 36MB file that you've processed and are now ready to send to your photographic lab. The resolution from this file is easily suitable for a 16 x 20 size print with little or no resolution changes. If the file is going to be printed at 30 x 40, then the file resolution must be resampled to match the set resolution of the printing device, which could require the file size to rise to 80–140MB. Resampling can be achieved in Photoshop under Image → Image Size.

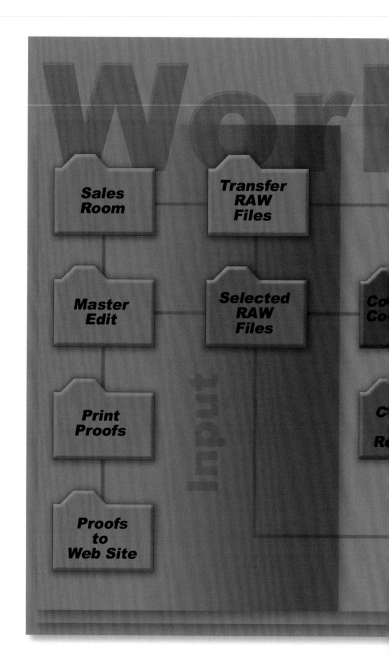

Sharpening

> Sharpening an image requires an increasing contrast of pixel data, thus removing pixel data in the process. Because of this data loss, sharpening for output should be one of the very last steps and established for a particular output size. (See the section "Sharpening" later in this chapter.)

Converting color space

> Converting the color space of the file to the color space of the printer is when color management is truly performed.

The good news is that, in most cases, when you send your 36MB RGB file to your lab, it will use a software RIP that automatically performs these three important steps.

With an in-house workflow to your own output device, you have several options to automate the output stage. You can create an action in Photoshop that will resample the image (if needed), sharpen it, and bring up the "Print with Preview" window, at which point you can select the output profile for your ink/paper combination and then establish the print driver interface. Or you can use a software RIP to apply these same options (more on this in Chapter 4).

ital Capture

flow

output

Process

Sharpen Image
*** * ***

Apply ICC Output Profile

Output

Archive

Archive your processed and original files prior to the output stage. Once your files have been resized, sharpened, and color space converted to an output device, they can be used only for that specific output in the future.

© Eddie Tapp

RGB or CMYK?

Output devices are either RGB or CMYK. Ink-jet printers use CMYK inks (and sometimes light CMYK inks). However, when you send a file to an ink-jet printer, send RGB files and the print driver or RIP will disseminate how ink will be applied to the paper.

Unless you are preparing files for a printing press that requires CMYK files, such as files for a magazine or newspaper, you are working in an RGB environment and your files should be processed, saved, and archived in RGB mode. If your RGB file needs to go to a printing press, then converting to CMYK should be included as one of the last steps. If you do not have an ICC profile to convert to or, even then, if you are not familiar with the properties for converting to CMYK, ask for prepress assistance from the printing plant or a press ICC profile to convert to, or let the printing plant do the final CMYK conversion to avoid potential conversion or press problems. (More details for this step are covered in Chapter 4.)

File and Printer Resolution

Resolution is a subject that confuses many people. There are all sorts of rules out there about what is best. The best way to understand resolution is to get a general understanding of how it works and then test it yourself.

As we learned in the "Input Stage" section of this chapter, input resolution is defined in pixels per inch (ppi). An image is no more than a file that has both a width and a height consisting of a certain number of pixels. A file does not consist of dots per inch (dpi). The dpi is relevant only when you go to print your image, and

that distinction is the source of much of the confusion about resolution. If you size a file for output, first set size in inches and then set the resolution that conforms to the output resolution. This information is placed in the header of the file so that applications and output devices know the size that you want to print to.

> Output resolution is defined as dpi for ink-jet and continuous-tone devices, such as dye sublimation and photographic paper printers. On a printing press, output is expressed as lpi (lines per inch).

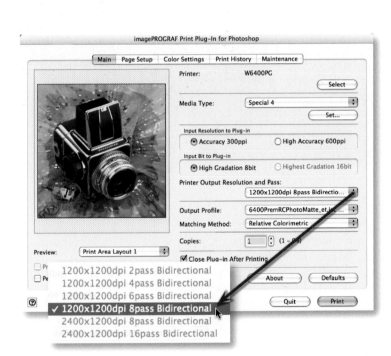

For example, most ink-jet printers will print anywhere from 150 to 2880 dpi. Do you need to print at the highest resolution? It depends on many factors, including the printer, the paper, screening, the speed of printing, and the often overlooked issue of viewing distance. Let's look at each of these issues:

Printer resolution variation

Different printers have different resolutions, and even though one printer has a higher resolution than another, the quality of the output is the main thing to consider. As with camera megapixels, printer dpi is often a marketing number (read: hype). A higher dpi printer will print more dots per inch, making the print appear smoother. Most ink-jet printers now print with additional light inks for some of the colors, and this helps make the print look smoother or more continuous.

Paper choice

Papers range from high gloss photographic to fine art rag, with a variety of speciality papers in between, including canvas and backlit. Ink-jet printers do no more than spray ink out of a nozzle onto paper. When the ink hits the paper, each type of paper responds to the ink differently. High-quality glossy papers accept the ink without spreading very much. Matte rag paper, on the other hand, spreads the ink out. For this reason, you can often print at a lower resolution on a matte surface paper than a high-gloss paper because the spreading ink suppresses the dots.

Screening

Screening is the way the dots are laid down on the page. Ink-jet printers use several types of screening, including stochastic and error diffusion. The details aren't important—just remember that screening can affect how the image looks on the paper.

Print speed

Speed is very much affected by the resolution at which you print. The higher the resolution, the slower the printer. If time is not an issue, you can print at the highest resolution. On the other hand, if you are trying to produce a lot of work in a limited time, you may want to consider printing at a lower resolution.

many people think that if you print at a lower resolution, the color is not as good. For the most part, with proper color management, the color at higher resolutions should match that of lower resolutions.

Image © Eddie Tapp

Viewing distance

> The rule of thumb is that the greater the viewing distance, the lower the dpi needs to be. A 4 x 6-inch print generally needs to printed at a higher resolution than a 30 x 40-inch print because the latter will be viewed a greater distance.

Ultimately, the goal is to send the smallest file size to the device that yields the best results. Keeping the file sizes smaller will speed up your workflow and save hard drive space. Here is a starting point for setting output resolutions for various devices:

- **Ink-jet: 150 to 360 dpi**

- **Photographic paper: 200 dpi**

- **Dye sub: 150 dpi**

- **Printing press 150 lpi (lines per inch): 250–300 dpi**

The best way to determine the optimum resolution for your printer is to test it yourself. When you have a healthy file (meaning good tone and color values), you gain what I call the "forgiveness factor" when it comes to getting the most out of a printer from the file resolution. Once again, good exposure and white balance can go a long way. I've printed images as large as 40 x 60 inches on an ink-jet printer from a 50MB file with superb results.

Sharpening

In a basic sense, *sharpening* is increasing contrast (removing pixel data), especially around contrasty edges, thus emulating a sharper image. The more pixel data that is resident in the file, the more sharpening you can apply with excellent results.

> You might sharpen during the process stage for visual sharpness, and you might sharpen again for ouput.

With the exception of processing a RAW file within a RAW-processing application, processing a file to achieve better color and tonality takes the pixel data and removes it, thus creating weaker pixel data but improving the visual appearance. This is also the case when you're sharpening an image.

Three factors come into play for sharpening a file for output: the type of the original image, the output size of the image, and the device that is printing it.

Type of image

An image such as a landscape generally requires more overall sharpening than a portrait does. Images sometimes require selective sharpening in different areas, such as sharpening of the eyes and lips of a portrait.

Output size of the image

To maintain the quality of an image, sharpening must be preformed after resampling in Photoshop. Sharpening an image for an 8 x 10 would require settings different from those required for a 30 x 40-sized image.

Image © Eddie Tapp / Model: Teri Ferguson

Output device type

Some output devices require more sharpening of the image than others. Such is the case with a printing press because when the ink is placed on the paper, the ink spreads out. This is called *dot gain* (take an ink pen and touch it to paper, and you'll see the ink spread). Dot gain causes the image to print slightly softer than the original image. Because of dot gain, you might need to seemingly oversharpen the image to get the right sharpened look when the image is printed. An ink-jet printer is considerably different from a printing press, so you will need to experiment to achieve the proper sharpening.

Some output devices have software that can sharpen an image for the size being printed. With this in mind, when you send files to an outside vendor, such as a photographic lab, check with the lab regarding the level of sharpening needed, if any. Again, as with an ink-jet printer, you will need to experiment with sharpening at different degrees to find what works best.

There are many techniques for sharpening images in Photoshop for output, including the Unsharp Mask and Smart Sharpening filters. The Unsharp Mask filter offers controls for the percentage of sharpening, a pixel radius to control edge contrast, and a threshold to smooth non-edge areas. The Smart Sharpening filter has additional controls to minimize Gaussian, Lens, or Motion blur, and an Advanced button that allows you to control the blending of edges where you might have a halo effect (which is normal when sharpening).

An excellent third-party plug-in to Photoshop is the NIK Sharpener Pro filter. This filter is my personal favorite because it has superb controls that are easy to use and takes into consideration viewing distance, print size, printer resolution, and type of media. It also works well in an environment in which many people are working on images, so you can achieve better consistency among operators.

Preparing Files for the Internet

Preparing files for the Internet is one of the more difficult challenges during the output stage because you really don't know how the audience's monitors may (or may not) be calibrated and profiled. On the other hand, outputting images for the Internet is certainly easy to regulate within a color space. And it is possible to use a system profile (monitor profile) to funnel a space of color before converting to the final output color space with certain types of image files, such as monitor screenshots.

Considerations for preparing files for the Internet include downsampling the file to specific pixel dimensions rather than a file size, sharpening (which we discussed earlier in this chapter), and setting color space:

Downsampling

In a general workflow, large files can be resampled in Photoshop using Image → Image Size. With Resample Image checked and Bicubic Sharper selected, you can then type in the actual pixel dimensions and select OK, and the image will downsample and sharpen for the smaller size.

```
                          Convert to Profile
 ─ Source Space ──────────────────────────────────            ┌────────┐
  Profile:  ProPhoto RGB                                      │   OK   │
                                                              └────────┘
 ─ Destination Space ─────────────────────────────            ┌────────┐
  Profile:  [ sRGB IEC61966-2.1            ▲▼]                │ Cancel │
                                                              └────────┘
 ─ Conversion Options ────────────────────────────            ☑ Preview
  Engine:  [ Adobe (ACE)          ▲▼]
  Intent:  [ Perceptual           ▲▼]
  ☑ Use Black Point Compensation
  ☑ Use Dither
  ☐ Flatten Image
```

Setting color space

A file color-managed for the Internet should be kept in a small color space, such as sRGB. Convert the color space in Photoshop under Edit → Convert to Profile; select sRGB if the file is in a different color space. Note that tagging a file with a color space such as sRGB will create a larger size file than one with no color profile. If this is an issue with images you are uploading to the Internet, you can choose not to embed a profile to keep the files as small as possible.

Occasionally, when an image color appears way off on the Internet, funneling the color space first into your calibrated monitor's profile via Edit → Assign Profile (and selecting your monitor profile) and then converting via Edit → Convert to Profile and selecting sRGB may funnel the color into a proper viewing condition.

BATCH PROCESSING FOR INTERNET OUTPUT

Prepping files for output on the Web can be automated via batch processing. One way to do this is to record an action in Photoshop. To do so, use the Image → Image Size command along with Edit → Convert to Profile. Once this action is recorded, you can use File → Automate → Batch from the Photoshop main menu, select the action, a folder of images, and batch process these images with your action.

My favorite method for batch processing for the Internet is using Image Processor. Go to File → Scripts → Image Processor in Photoshop (or from Adobe Bridge, select Tools → Photoshop → Image Processor). Here you can select "Resize image," type in the pixel dimension, select "Convert Profile to sRGB," and batch process all your selected images from the Bridge.

When you batch process in this way, in order to obtain the Bicubic Sharper option for downsampling, you have to set your preferences ahead of time. In Photoshop under Edit → Preferences → General (Windows), or Photoshop → Preferences → General (Mac), select Bicubic Sharper from the Image Interpolation pull-down menu, which will then become the default setting. Now, when you use the Image Processor from either the Bridge or Photoshop, Bicubic Sharper will be used.

Bonus Step: File Archiving

File management, archiving, and storage should be your first consideration when establishing a digital workflow, but they are often the last considerations and can cause serious bottlenecks in a workflow until a system is established.

I am one of the guilty parties. Early in the process of establishing my digital workflow, I remember having to back up files on CDs at the end of the day so that there would be room on the hard drive to continue the next day's work. This was a very time-consuming, frustrating, and costly method of file management. Eventually, working with a server and/or additional hard drives allowed for a much smoother workflow.

This chart shows how a portrait studio's file management, storage, and backup might require 1.5 terabytes of manageable space for one year. Conservatively speaking, the daily file management would take place on a server, and given a six-week (five-day week) cycle, an 80-gig server would handle this workflow. After the six-week cycle, the files would be moved to a more permanent backup and storage system.

When designing your network, including a server to manage your files can allow for a more productive workflow because you can have multiple workstations open while processing and saving files back to the server.

File Storage

5 Sittings per day 20 images per session 10 megapixel RAW files	=	1 gig	
• 4 selected images Customer order for processing	=	Add 1 gig	
• 6 week cycle	=	80 gigs	
• Manageable files for 1 year	=		680 gigs
• Backup system 1 year	=		1.5 TB

Basic Network

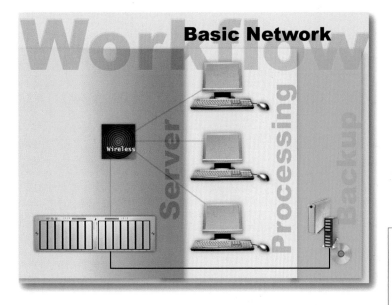

For more on archiving, storing, cataloging, and protecting your files, check out Peter Krogh's The DAM Book: Digital Asset Management for Photographers (O'Reilly).

Three Stages of Color Management

Like the general workflow that provides the structure for sound color management that we discussed in the previous chapter, the color management workflow can also be divided into three steps: establishing a working color space, calibrating and profiling devices, and converting to the output profile. Establishing and maintaining these details is the means to generate the color consistency that you want.

Contents

Chapter **4**

Establishing a Working Color Space

Choose a working color space that is optimized for your particular image-editing workflow. Which color space you use is less important than how you manage it. We'll start with simple color spaces. You can use a more advanced working color space once you are ready to move on to the next level.

Which One Do I Pick?

Here are five scenarios for choosing different working space setups in Photoshop:

sRGB: gamma 2.2, 6500K
Use only when sending files to a photographic lab that requires sRGB or when creating files for the Internet.

Adobe RGB (1998): gamma 2.2, 6500K
The most popular working color space. Use for ink-jet printing, prepress, and photographic labs.

Apple RGB: gamma 1.8, 5000K
Use for legacy Apple monitors; similar to sRGB.

ColorMatch RGB: gamma 1.8, 5000K
Use for prepress, preparing files for a printing press, or newsprint.

ProPhoto RGB: gamma 2.2, 6500K
The largest working color space. Encompasses an advanced color management workflow.

When choosing your working color space, it is best to consider your primary output. For instance, if your work is usually printed in-house on an ink-jet printer, Adobe RGB (1998) or ProPhoto RGB is a good choice. If you send files to a photographic lab, check with the lab to see if it has color space requirements, and if it does, use that color space as your working space. Note that you don't *have* to use the same space that the lab does;

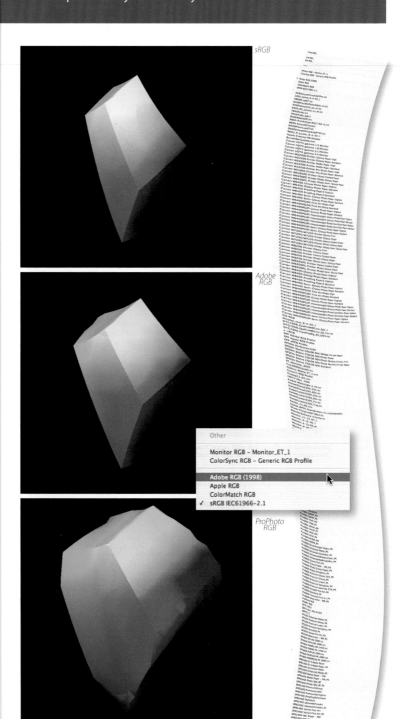

doing so can help in production, but it isn't completely necessary.

If you have an ink-jet workflow in addition to your photographic lab workflow, one option is to use Adobe RGB (1998) as your working space and convert to the lab's space when you're ready to send the file. At the end of this chapter, I'll show you how to establish an action to convert to sRGB and save in a folder ready for the lab.

NO SPACE LIKE HOME

There are three types of color spaces a file might have: an input profile (such as a scanner or digital camera profile), a working color space profile (such as ProPhoto RGB used during the image-editing phase), or no color space profile. I refer to a file's color space as a "home." So, when a file has a color space, it has a home, and when there is no color space embedded, it has no home. A color-managed workflow is much easier when a file has a color space home to start with.

Adobe Bridge showing embedded profiles

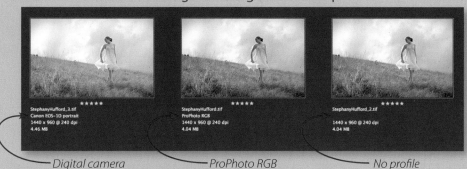

StephanyHufford_3.tif
Canon EOS-1D portrait
1440 x 960 @ 240 dpi
4.46 MB

StephanyHufford.tif
ProPhoto RGB
1440 x 960 @ 240 dpi
4.04 MB

StephanyHufford_2.tif

1440 x 960 @ 240 dpi
4.04 MB

Digital camera *ProPhoto RGB* *No profile*

If a file has no home (color space) these days, it is usually because it was created or scanned before color spaces were tagged in files. Or perhaps it has gone through a process where no ICC profile was included; for instance, it's gone through the Image Processor in Photoshop with the option "Include ICC Profile" (see the bottom of the screen) left unchecked. When this box is unchecked, the processed images are stripped of any home color space they started out with. Processing a file without an ICC profile is sometimes done for the Internet or when requested by an end user.

Setting Your Working Color Space

You can set your working color space in Photoshop under Edit → Color Settings. This opens the Color Settings screen where you can select the RGB working space that is suited for your particular workflow. Photoshop is quite capable of managing any color space a file is tagged with, and even more impressive, Photoshop can handle multiple color spaces (from multiple open files) all at the same time.

At the top of the Color Settings window is a drop-down menu for choosing a set of overall Settings. (In this example, it's set to the default: North America General Purpose 2.) This setting gives you specific working spaces for each color model; in this case, sRGB IEC61966-2.1 is the default RGB Working Color space along with U.S. Web Coated SWOP v2 for CMYK and Dot Gain 20% for Gray and Spot.

You can set any of the items in the Working Spaces box independently. For RGB, there are four primary choices: Adobe RGB, Apple RGB, ColorMatch RGB, and sRGB. My personal choice for my working color space is Adobe RGB because my workflow includes processing images for ink-jet printing, photographic labs, and prepress, and this working space covers most of these output gamuts during conversion.

I do, however, embed ProPhoto RGB in all of my RAW files when I process them through Adobe Camera Raw in order to preserve the highest amount of pixel data for current and future use.

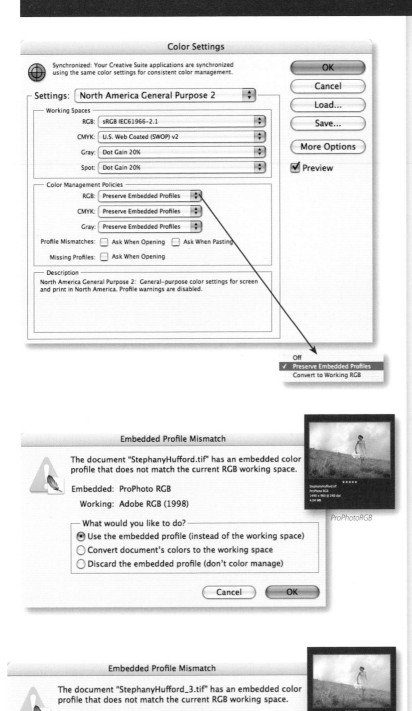

ProPhotoRGB

Digital camera profile

In the next box are the Color Management Policies options. The default setting for each color mode is to Preserve Embedded Profiles, which is the best choice when you work with images that have various embedded profiles. From each of these drop-down menus, you can also choose "Convert to Working RGB," which is a good choice when you have a closed loop workflow (such as shooting with one camera and printing to one printer) or if you are processing images for use on the Internet. "Convert to Working" RGB is designed to automatically convert files to your chosen working space according to the model (i.e., RGB, CMYK, Gray) when you open them in Photoshop. The Off option will pass the files straight through, but Photoshop may display a message when you open a file to remind you that the tagged file is different from your chosen RGB working space.

Mismatch warning

Checking the options for when Photoshop should ask you about Profile Mismatches and Missing Profiles will cause Photoshop to display a warning when you open images that are not in your working RGB color space. The warning will show you which profile is embedded and options to manage the document's profile. If a file has a color space home, keep it by selecting "Use the embedded profile"; that is the best policy unless the embedded profile is from an input profile such as a scanner or digital camera. In that case, choosing "Convert document's colors to the working space" will convert the color space into your color space workflow.

In a color-managed workflow, when a file has no embedded profile, you certainly want to assign one to it. Photoshop offers two choices for assigning a profile, and which one you choose depends on the source of the file. In most cases, the second choice, "Assign working RGB," is best. If you have a scanning or digital camera workflow but the device does not apply an input profile, choosing an "Assign profile" option from the pull-down menu allows you to select the scanner or digital camera profile that works best. You also have the option of then converting to your working RGB, which is the best choice in most cases.

Photoshop also offers one of these options: "Leave as is (don't color manage)" or "Discard the embedded profile (don't color manage)." These options are handy when you must process images with no profile embedded. If you have a file with a tagged profile but your lab requests an untagged image, from the main menu in Photoshop you can choose File → Save As…. In the Save As dialog box, you'll find an option at the bottom to uncheck Embed Color Profile. This will strip the embedded profile for your lab's requirements.

In creating screenshots for this book, I did not have embedded profiles. In this case, I chose "Assign profile," selected my calibrated monitor's profile, and then checked "and then convert document to working RGB." This funneled the color of the screenshot to maintain the proper color appearance. Using this technique also works very well for images you prepare for the Internet.

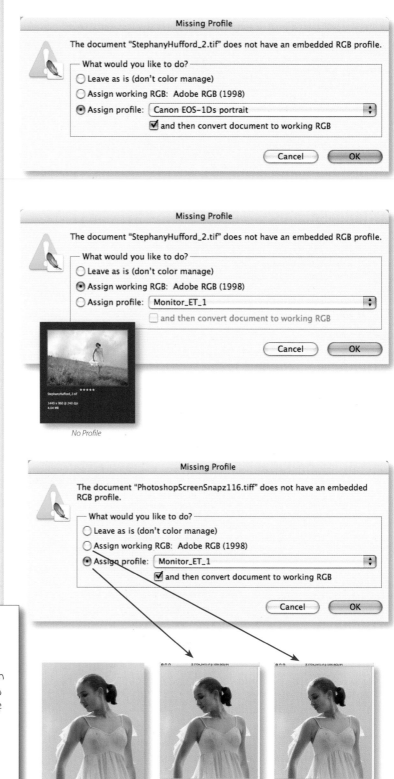

No Profile

Original

Assign profile and then convert to working RGB

Assign working

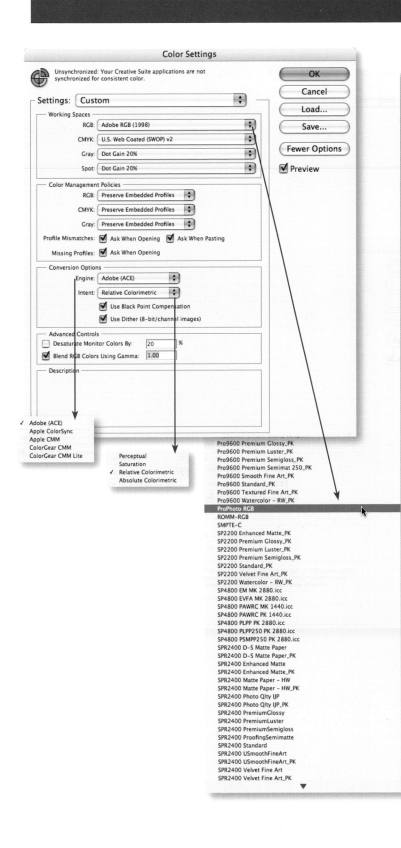

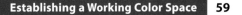

Advanced options

Click on the More Options button to expand the Color Settings window. You now have Conversion Options, Advanced Controls, and if you select the RGB drop-down menu in Working Spaces, you'll notice a gazillion choices for a working space. (Here you can choose ProPhoto RGB as your working space, but select this profile only if you are an advanced user.)

In the Conversion Options box, you can set a couple of the items we learned about in Chapter 2. The default engine, Adobe (ACE), works very well when converting profiles in Photoshop. (The engine is the Color Management Module that we discussed in Chapter 2.) Adobe (ACE) is the best choice unless you have a specific reason for using a different engine. What you select for the other options will depend on your operating system and any other software you may have installed. Here you can also set your Rendering Intents (as we discussed in Chapter 2). Relative Colorimetric and Perceptual are the two most commonly used rendering intents. In a basic workflow, consider Relative Colorimetric for ink-jet printing and Perceptual for photographic paper printing, such as your lab might use.

Checking the Use Black Point Compensation options will compensate the black point of your image according to your (properly calibrated) monitor's profile. When the known values of a black point are displayed on your monitor, this option attempts to replicate this known black point. Using Dither (8 bit/channel images) will ease the transition between profiles where banding may become apparent. Both options should be checked.

With so many options to pick from, choosing the right ones can seem overwhelming to say the least. But establishing your working spaces and color management policies is of the utmost importance. With the exception of selecting sRGB as a working space in most cases, using the default settings on everything else works well and is recommended for a basic color settings setup.

In the Advanced Controls, you will find the option to Desaturate Monitor Colors by a specific percentage. This option is rarely used today, even though it does offer compensation for overly saturated monitors once a consistent workflow has been established. The Blend RGB Colors Using Gamma option is designed to dither your brush edge with certain color blendings, which may result in fewer edge artifacts.

In the Description box at the bottom, you'll find a wonderful amount of information regarding anything that your cursor hovers over. Position your cursor over any part of the Color Settings window to read a brief description of a profile or option.

CREATING CUSTOM PROFILES

Photoshop gives you the option to create custom profiles for all working spaces. For instance, CMYK custom workflows can use Photoshop's default presets, a custom ICC profile (preferred), or custom settings for a particular printing press. To establish custom CMYK settings, from the Working Spaces CMYK pull-down menu, select the top option, Custom CMYK, which will bring up the Custom CMYK window.

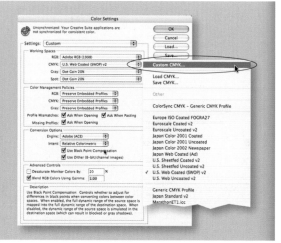

CREATING CUSTOM PROFILES (continued)

In the Custom CMYK window, you can select the Ink Options and, more importantly, the Separation Options. When a file is converted to CMYK, the values and percentages of ink that will be resident on each of the C, M, Y, and K channels is critical information for the printing press because those numbers represent how much ink will be applied to the paper during a press run. For instance, a web press applies much less ink than a sheet-fed press does. The first consideration is the separation method, and the two choices are GCR (Gray Component Replacement) and UCR (Under Color Removal). Once you select one of these options, you can then establish the other properties, such as Black Ink Limit, Total Ink Limit, and, in the case of GCR, UCA Amount (percent of Under Color Adjustment), if any.

When you're working without a custom ICC profile, this setting is certainly the key to establishing the proper method for converting to CMYK in Photoshop. Obtaining this type of information today is quite easy. Just ask your prepress house or even the printing company for the information. (Early on in digital prepress history, this information was not so easy to get.) Once the profile is set up this way, it can ensure a great press run.

In this example, using the data from my printer, I created a GCR separation setup using 90% Black Ink Limit and 320% Total Ink Limit with 0% UCA. Also notice that I've named this with my tag, TMAX.

With more options selected, you can also create a Custom RGB profile, but we used Custom CMYK in this example because it's used by more photographers

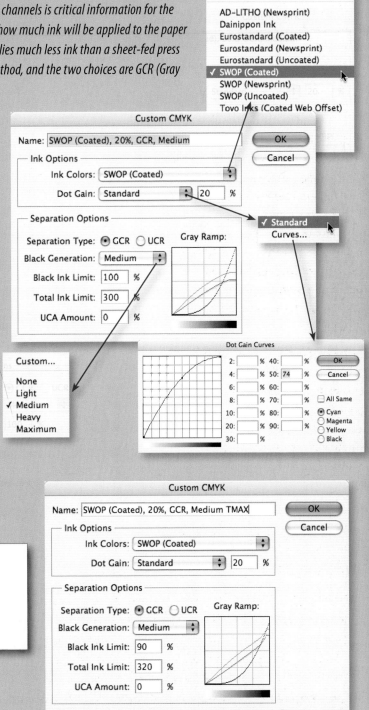

Saving Your Color Settings

Whether you choose customized or established settings, be sure to save them by clicking the Save button. A dialog box will appear in which you can name your settings something useful; I've named mine TMAX3. When you save your color settings, a Color Settings Comment window will appear, so you can type in any specific instructions or comments regarding your color settings.

Saving these settings will create a *.csf* file in the *Applications Support* folder in your system. You can send this file to other workstations. From the Color Settings window, select Load to load the same settings on the new workstation without having to match the settings manually.

TMAX3.csf

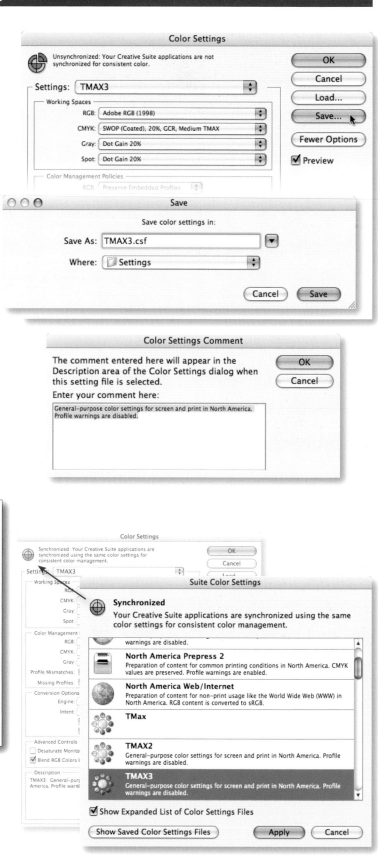

If you are using Adobe's entire Creative Suite, you may notice the Synchronized or Unsynchronized icon in the upper-left corner of the Color Settings dialog box. You can synchronize your color settings across all the Creative Suite applications by choosing Edit → Creative Suite Color Settings in Bridge. Here, you can choose any of your saved color settings, which will then be applied to all of the Suite applications. Once you're back in the Color Settings window, the settings will then show the Synchronized icon.

Original color space: Adobe RGB (1998)

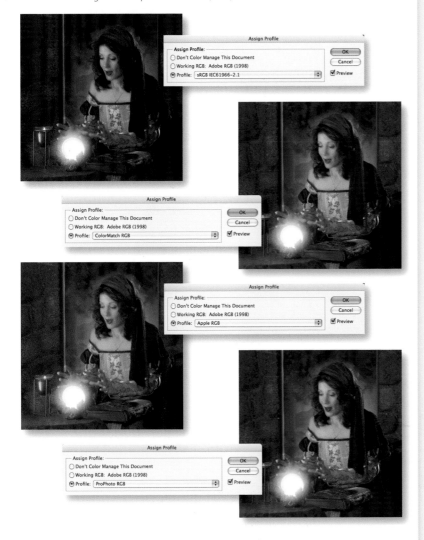

Assigning Versus Converting Profiles

In the course of a normal workflow, assigning profiles isn't a usual procedure. However, as this illustration shows, assigning a different color space to an image can contract or expand the appearance of the color gamut and gamma, depending on the original color space (Adobe RGB (1998) in this example).

It's important to understand the distinction between assigning and converting profiles. Converting profiles will maintain the same color appearance while actually changing the numeric pixel data. Assigning profiles will not change the numeric pixel data but can indeed change the color appearance.

Assigning profiles is most successful when assigning an input profile from the device in which the image was originally created, such as assigning a scanner profile after the scan, and then converting it to a working space. (This is, however, done mostly within the scanner software so it remains seamless.)

To assign a profile from the main menu in Photoshop, select Edit → Assign Profile. In the Assign Profile dialog, "Don't Color Manage This Document" allows you to untag a color space via the selection. Using the second choice, you can apply your working color space. The third choice gives you a drop-down menu that shows the profiles available in your system. With Preview checked, you can easily see how assigning a different profile will affect the appearance, but the numeric pixel data will remain the same. Think of this as placing a filter of sorts over the image.

If you set your Color Settings set to "Ask When Opening for a missing Profile" and you open a document with no profile embedded, you will be given options to assign your working space or assign a profile. You can then choose from the same pull-down menu as discussed in the previous section.

Converting profiles does indeed change the pixel data. However, because Photoshop automatically takes advantage of the CMS (as explained in Chapter 2), when you choose "Convert to Profile" in Photoshop, you will see very little (if any) changes in the color appearance because Photoshop is considering the color space of the file and the color space it is converting to before displaying this information through your monitor's calibrated profile. In this way, Photoshop automatically emulates what is known as a "proof view."

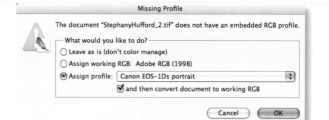

Missing Profile

The document "StephanyHufford_2.tif" does not have an embedded RGB profile.

What would you like to do?
- Leave as is (don't color manage)
- Assign working RGB: Adobe RGB (1998)
- Assign profile: Canon EOS-1Ds portrait
 - ☑ and then convert document to working RGB

Cancel OK

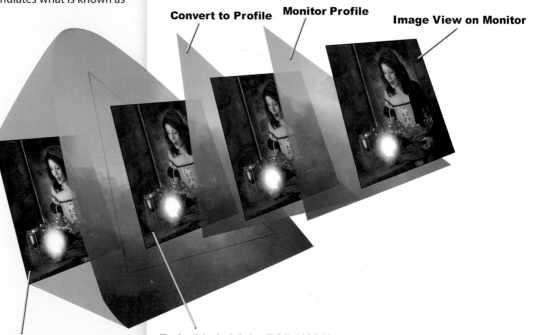

Convert to Profile **Monitor Profile** **Image View on Monitor**

Original Image Data **Embedded: Adobe RGB (1998)**

And speaking of proof view, you can proof your colors by choosing View → Proof Setup → Custom and then selecting the ICC profile that you will be printing to. Photoshop will display your image as if it had been converted to that profile. Using Proof Setup will emulate out-of-gamut colors and tones, allowing you to make corrections and adjustments in the file's current space if needed. Designed primarily to help view out-of-gamut color when converting from RGB to CMYK, this feature works with any output ICC profile.

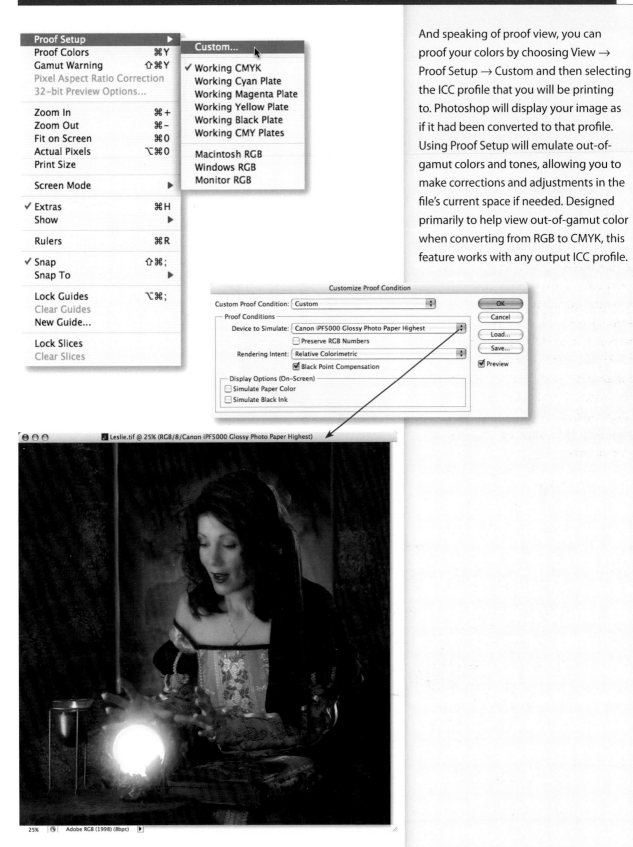

Calibrate and Profile Devices

Stage two in a color-managed workflow is to calibrate and profile the devices in your workflow. There are five types of devices that need to be properly calibrated and profiled in your color management system: scanners, digital cameras, monitors, printers, and projectors.

As we've already noted, to calibrate a device is to bring it to a known set of standards (such as a color temperature and gamma setting). Once the device is calibrated, you can create an ICC profile in its calibrated condition. When the profile is used in a workflow, it can communicate its specifications from one device to another to yield consistent results.

Maintaining a machine in its calibrated condition is important for predictability of results over time. If a device shifts from its calibrated condition, the profile will yield inconsistent results, requiring recalibration. It sounds simple, and it is; even though some devices might require a more complex procedure, most devices are very easy to calibrate.

GretagMacbeth Eye-One Match 2 interface

Macintosh system calibration tool for OS X

Basic Device Calibration

Here are the basics of device calibration for devices you may have in your workflow.

> In Chapter 5, Rick will cover a more advanced means of performing the calibration process for scanners, digital cameras, and printers.

Calibrating digital cameras

Calibrate a digital camera by using a custom or preset white balance. Doing this will calibrate the camera to the lighting conditions and set a color temperature. Couple this with a good exposure, and you have the basic calibration needed for consistency. The challenge comes from the many varied lighting conditions in which you might be shooting. You may need to recalibrate the digital camera for each lighting condition.

Calibrating scanners

When you turn on a scanner, you can hear the scanner head moving across the bed (assuming it is a flatbed). The scanner is performing a basic calibration. Most scanners are able to calibrate themselves reasonably well. (Before scanning, you should thoroughly clean the glass of the scanner to minimize dust spots.)

Calibrating monitors

You have two choices when calibrating monitors. The first is to use a built-in, system-generated method of calibration. The second and more accurate method is to use a combination of hardware, a measuring device, and software such as the Eye-One Match software by GretagMacbeth.

The operating-system-generated method is subjective and may not yield consistent results over time. Using monitor-profiling software, you will be asked which white point, gamma curve, and luminance value to calibrate to. If your monitor or display controls allow, you may select a color space, color temperature, or other controls that include individual color controls for red, green, and blue; brightness; and contrast, allowing you to optimize your monitor during the calibration procedure.

If your monitor does not offer some of these controls, you are better off with a software/measuring-device approach. Monitor-profiling bundles cost anywhere from $69 to $300 and beyond. With monitor-profiling solutions, the software will prompt you through the process step by step with explanations and diagrams.

A sensor will read a series of color patches on the screen to determine its current condition for color temperature, gamma, and luminance and will ask you to adjust monitor controls until you are as close to your set of preferences as possible.

As I mentioned at the outset, profiling a monitor is a two-step process in one session:

1. **Calibrate the monitor.**

2. **Create and save the profile.**

Let's take a closer look. Begin by turning on your monitor and allowing it to stabilize one hour before you start to calibrate.

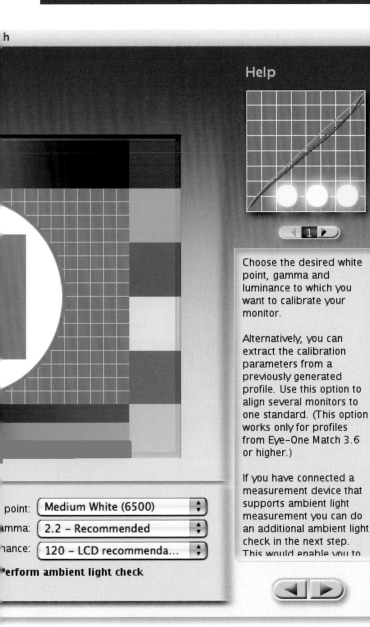

GretagMacbeth Eye-One Match 2 Settings window

Ideally, there should be no window light influencing your view of your monitor, as brightness levels, changing color temperatures, and overhead lights can affect how you see what's on your monitor. A monitor hood is an excellent solution in these conditions and can help keep ambient and stray light off the monitor.

First, decide on the white point for your monitor. For most workflows, 6500K is recommended because most monitors natively have this color temperature or close to it. However, many CRT monitors are set to 9300K (known as "TV blue") by factory default and need to be set to 6500K using the monitor controls. Most monitor-profiling software allows you to calibrate and profile the monitor using a native white point, which is the preferred method for LCD monitors or laptops. Another reason for using a white point of 6500K is that it matches fairly closely to a standardized 5000K light source, which is an industry standard for photography and graphic arts in the United States.

Once you have decided on the color temperature, you'll need to determine the gamma setting. The typical gammas that are available are 1.8 and 2.2. In the old days, Macs used a gamma of 1.8 and PCs used 2.2. Today, a gamma of 2.2 is best for both platforms.

I recommend a luminance setting of 120 for LCD monitors and 100 for CRT monitors. This setting is especially important if you wish to set multiple monitors to match each other as closely as possible.

If you're using an Apple Cinema Display and the luminance value is too high, use the Apple Cinema Display control panel to reduce the brightness slider, allowing you to get closer to the large luminance value. Don't worry if the numbers are slightly different.

CRT monitors usually need to be recalibrated twice a month because they tend to change over time. LCD monitors are much more stable and need to be recalibrated only about once a month.

There are a number of monitor-profiling software packages and measuring instruments available. The Eye-One Display 2 from GretagMacbeth and the Monaco Optix XR from X-Rite come as a bundle. Others, such as basICCcolor Display, include only software and require you to purchase your own instrument.

Calibrating printers

Some printers have a means of automatic calibration or self-calibration built into their systems. Most ink-jet printers have utilities for head cleaning and print head alignment, which is a basic form of calibration. Higher-end ink-jet printers such as the HP 5500 have a measuring device built into the head to perform calibration. Other ink-jet printers that are supported by third-party raster image processors (RIPs) often include tools to calibrate or recalibrate themselves. The majority of ink-jet printers are relatively stable.

Image © 2005 Tim Olive / www.olive.com

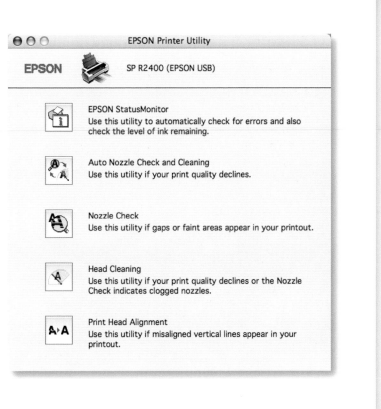

To achieve optimum results with an ink-jet printer, use the printer's utility to check the nozzles and print head alignment. This can usually be done from either the printer menu itself or a utility located in the driver. If the nozzles are not firing properly, you will see broken lines in the pattern created during the test. Select Head Cleaning to clear the nozzles. It may take several cleaning cycles in a row to fix the problem. If the heads are firing correctly and you see small horizontal lines on your prints, you could have a problem with head alignment. You can print out a different target pattern and see if the alignment is off. If it is, then it can be adjusted from either the printer menus or the print driver utility. Check the alignment whenever you install a new printer or move the printer to a new location.

Nozzle check test pattern for an Epson 2400

Nozzle check test pattern after cleaning

Some ink-jet printers on the market today give you the option to perform both print head alignment and nozzle cleaning automatically.

Dye sublimation (dye sub) printer calibration is usually software driven. Some of these printers require you to print out a series of patches, select the most neutral patch (which is numbered) in the software, and type in the patch number in the window provided.

Most higher-end color laser printers have a means of calibrating themselves; however, lower-cost laser printers do not offer any means of calibration.

Calibration is critical for consistent color because these devices drift due to temperature, humidity changes, and possibly the global political situation (or what I call mysterious gremlins). Some lower-cost color laser printers from Xerox have the option of calibrating with software called Phasermatch. You can adjust this software either visually or with a measuring instrument.

Many higher-end color laser printers have software RIPs, and some of these RIPs have a means of performing calibration with their built-in scanner or with a measuring device (see Chapter 5 for more RIP details).

Some photo labs use chemically based calibration, which is performed by printing out tests on a control strip. This strip is usually a grayscale step wedge, which is read with a densitometer that calibrates the printer in its software. Calibration of these types of printing devices is done on a daily basis, but some labs will calibrate such printers several times a day, depending on the workload. This calibration compensates for the variability of the printer and the paper processor.

The GretagMacbeth Beamer, a projector calibration system

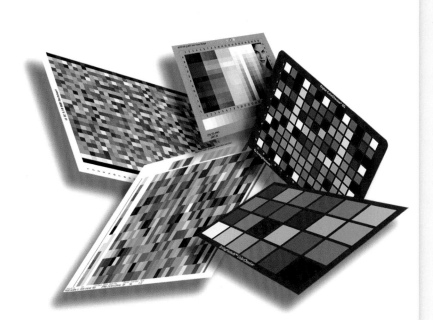

Printing presses are very complex devices and are difficult to keep calibrated. Printers use a variety of different test targets and measuring devices to keep the press in control. Good printers will run their presses to industry standards such as SWOP or GRACOL. If you've ever been on a press run and watched the pressman calibrate the press, it takes sometimes up to 1,000 sheets (if sheet fed) to get the presses stable (or calibrated) for the run. Ultimately, the point is that every device, even the most sophisticated, needs to be calibrated.

Calibrating projectors

With projectors, similar with a monitor, start with calibrating projector controls: set the color temperature or a color space such as sRGB, or manually adjust it with the individual controls for red, green, and blue. Once you establish this base, you can then use a measuring device (such as the GretagMacbeth Beamer attachment for the Eye-One) for calibrating projectors to a selected white point and gamma setting. The contrast ratio, or dynamic range, of a projector is somewhat smaller than that of a monitor, so contrast range may be different from your monitor. But in most cases, the color can actually be very close to a properly calibrated monitor.

Creating Device Profiles

Once your devices are calibrated, the next step is to create a profile to use in your workflow. Profiles can be created for each device using profile creation software. You may choose to have a professional create custom profiles for you, or you can even download profiles from the Internet.

Profiling digital cameras

Digital camera profiles are created by first photographing a chart, such as this ColorChecker SG by GretagMacbeth (shown on this page). The lighting must be perfectly even across the chart and properly exposed, preferably by using a light meter to check the exposure. You'll also want to make sure the camera is properly white balanced. By entering this image (of the chart) into camera profiling software, you can create an ICC profile for the camera.

Adobe Camera RAW

> If you are shooting RAW images and processing them using Camera Raw in Photoshop, Bruce Fraser has written numerous articles (and even an entire book) on how to calibrate and profile your camera (see the Appendix).

Note that this profile is best used in the lighting conditions that the chart was shot in. In my experience, I have found that camera profiles do not work for many situations. One of the many reasons that a profile won't work is that the target has a very limited range of colors compared to the real world. The software then tries to guess how the colors that lie outside the range of the targets should look. For this reason, in a majority of digital workflows, you would not use a digital camera profile

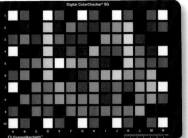

ColorChecker SG by GretagMacbeth

Imacon Digital Back on Hasselblad

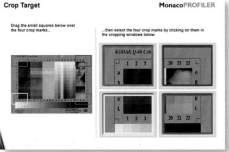

The Monaco Profiler, a scanner profile interface

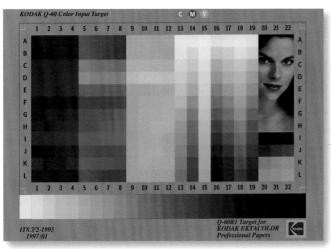

Kodak IT-8 target

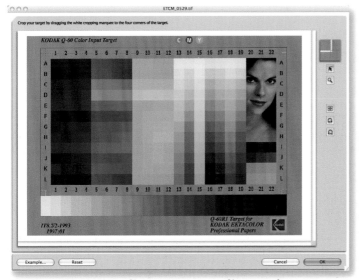

The GretagMacbeth Profiler 5, a scanner profiling interface

The ColorVision Spyder 2, a monitor calibration interface

per se. Instead, you might use the color space that the camera attaches to the file or manually select a working color space, such as sRGB, Adobe RGB, or ProPhoto RGB.

Digital camera profiles do work much better in a fine art reproduction workflow because you are working with a narrower range of colors compared to the "real world." Sometimes these profiles need to be edited for different types of artwork, and that type of workflow is where custom digital camera profiles are primarily used today.

Profiling scanners

Because of the limitations of scanner software, you cannot calibrate or create profiles for all scanners. Some of the low-end consumer or business flatbed scanners fall into this category. If your scanner's software does not have advanced color management options, there are several companies (including Lasersoft) that make good software. You will need to check with these companies to see if they support your scanner.

To profile your scanner, use an IT-8 target, available as both reflective (color print) and color transparencies and made by different manufacturers, including Kodak, Fuji, and Agfa. If you plan on scanning transparencies and reflective materials, you will need to create an ICC profile for each separately.

Before scanning the target, you need to set up the scanning software using manual or advanced rather than auto mode. Locate the preferences or advanced color control options, and select the No Profile, No Correction, or Off option—each interface is different.

Once the target is scanned and saved with no profile, you can then bring the file into a profile creation software application to create the scanner profile. In Chapter 5, Rick will cover a very comprehensive means of profiling scanners for a more advanced workflow.

Profiling monitors

When you create a profile for your monitor, the software will send a series of different color patches to the monitor. The software actually creates the monitor profile by comparing the color values of the patches displayed on the screen to the color values as measured by the sensor on the monitor. Using that data, it makes an appropriate adjustment to display color accurately. The first time you calibrate your monitor, the difference can be quite dramatic. Subsequent recalibrations will be less so.

Once you calibrate your monitor and have a monitor profile, the profile will be in good standing as long as you keep your monitor calibrated. So when you recalibrate your monitor on a monthly or bimonthly basis, there is no need to generate a profile each time.

Profiling printers

Profiles for some manufacturers are available online. You can also hire a professional color consultant to create custom profiles, or you can purchase the software and hardware to create them yourself, which is recommended. X-Rite/Monaco, GretagMacbeth, and Colorvision offer excellent packages for creating your own custom profiles. These packages usually include the means to create profiles not only for printers, but also for scanners, digital cameras, monitors, and even projectors.

VARIATIONS ABOUND

When I teach a workshop, I have everyone bring up the same image on their monitors. I have them use the screen mode in Photoshop with the black background and press the Tab key to hide tools and palettes. Then I bring everyone to the back of the classroom to see all the various color and tone renditions of the exact same image. Out of 20 monitors, only a few are close to proper rendition. And then after calibration and profiling, we again view all the monitors. Even then, a few don't match, perhaps caused by a monitor that was un-calibratable.

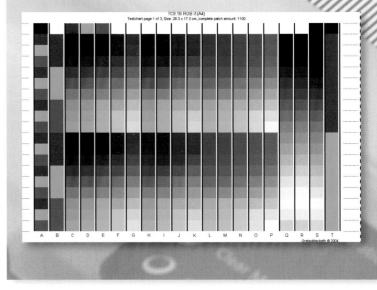

To create a printer profile with one of these packages, you must first print a chart of color patches. The software interface will give you step-by-step instructions on which chart to use and how to read the patches with a device known as a color spectrophotometer. Once the patches have been (properly) printed and read with the device, the software will give you options for creating the profile for a particular viewing or lighting condition.

When you're printing these color patches from Photoshop, make sure your Photoshop Color Settings have been established properly, as we discussed in the last section. Selecting the option "Leave as is (don't color manage)" will keep the values of the target native, which is critical for creating the profile. In Photoshop, select File → Print with Preview. You will see "Profile: Untagged RGB" in the Print area, and using the Color Handling Options pull-down menu, select No Color Management. This again will keep the values of the target native. It is also important to print the file at 100% to keep the patches at the proper size for the spectrophotometer. (It is okay to resample the file before printing if necessary to make the image prints large enough.)

After you select Print, leave Photoshop and go to the print driver. Select the printer that you are creating the profile for; in this example, we will use the Epson 4800. There are two areas that are critical to configure: the Print Settings, where you choose your media type, print quality, and printer resolution; and Printer Color Management where you select Off or No Color Management, ensuring that these patches will be printed in their native

state. Note that although the print driver interface looks different on a Mac (where you have drop-down menus) than it does in Windows (where you have tabs and an Advanced button), the options are the same.

The following are three important steps for using the print driver in a color-managed workflow:

1. **Select the Media Type for the type of paper that you are using. Each Media Type has been optimized for different paper types and takes into consideration the amount of ink the media will take and how the tones will be distributed on the paper. It may take some experimenting with different Media Types to find the one that works best for any third-party media.**

2. **When selecting the Print Quality (which is the printer resolution), you may want to experiment with different settings to determine what resolution works best for you. Some papers, such as luster and gloss, may need to be printed at a high resolution, while other papers, such as matte and canvas, work fine at a lower resolution. Keep in mind that the higher the printer resolution, the longer it takes to produce a print.**

3. **No Color Adjustment, No Color Management, or Off—whichever way your interface phrases it, selecting no adjustment means that the print driver will not attempt to make any adjustments or use a profile, allowing the image to print in its raw condition or native state.**

X-Rite, Pulse Elite System Output Profile interface

Anytime you change these settings in the print driver, you are affecting the color. Be sure to use the exact same settings for each media that you create a profile for. Also, note that you will need to create a separate profile for each distinct resolution.

In order to avoid having to go through all the options in the printer driver each time you print, you can save settings as a Preset once you have created a (or use any) profile (from the Presets pull-down menu, select Save As). When saving the preset, make sure you use a naming convention that is descriptive: include information such as the printer, paper, and resolution. Keep the name short so you can see the whole name in the Presets window, as I've done here by naming it *4800PremLust1440*.

Print the target and check for any problems, such as marks, lines, or scratches. Because inks need to stabilize, allow the inks to thoroughly dry before measuring the patches. Fifteen minutes is good for pigmented inks; however, the surface may take three or more hours to cure and become resistant to surface scratches, etc. A dye-based print may take up to 24 hours for the patches to stabilize and cure.

Reading the patches with your measuring device should be pretty straightforward; just follow the steps provided in the user interface. Your software will want to know which set of patches you've printed before starting, and then, depending on the device you're using, patches will be read with either a patch-by-patch, strip-by-strip, or completely automated (hands-free) method. After you have read in all the patches, the software will inform you

that you have been successful. When you close the window, you will be prompted to save the data.

Before the final profile is generated, it is important to select a viewing light source. D50 is a known standard lighting in the U.S., but if you are viewing under other lighting conditions, pick the one that is closest to what will be used. (If unknown, choose D50.)

ProfilerMaker Pro 5 (GretagMacbeth) gives you an option to "Correct for Optical Brightener," which becomes available if the paper that you are using has an ultraviolet optical brightener to make the paper appear whiter. To make the paper appear whiter, the UV brightener white is actually made more blue, which needs to be compensated for. Some spectrophotometers have a UV filter on them to prevent this problem. If you encounter a paper with a UV brightener and your measuring device does not have a UV filter, this option to correct will be available, and you should select it.

You are now finally ready to save your profile. Give it the same name as your measurement data so that you don't become confused. The next step is to use this profile to produce a great print, as we will discuss in stage 3 in the next section.

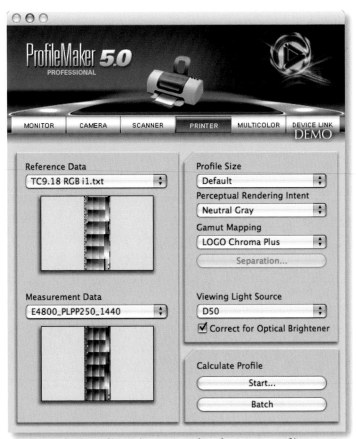

GretagMacbeth ProfilerMaker 5.0 interface for printer profiling

When installing a print driver for a printer, manufacturer ICC profiles are usually automatically installed into your system and ready to use.

And surprisingly, these profiles are becoming more useful in many kinds of workflows. Each manufacturer offers its own brand of paper, which has been optimized to work with its inks, dyes, or chemical processes. For ink-jet workflows, there are papers and even inks that are made by third parties to work with these printers. Some papers may not absorb the inks properly, and the color may not reproduce correctly, which would necessitate creating your own profile or obtaining one from the supplier, if available.

Profiling projectors

Projector profiles are created at the time of calibration. If your projector is stationary, one profile can be used over a long period of time. The same profile can be used by other computers that may use the same projector and screen. For projectors used at various locations and lighting conditions, create a profile for each location.

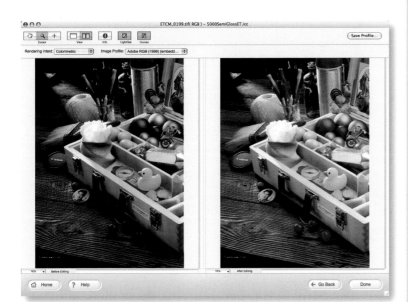
X-Rite Pulse Elite System profile-editing interface

Editing Profiles

You may need to edit your profiles to adjust for anomalies for a given device—perhaps open up shadows, add or subtract a percentage of color, etc. Doing this is similar to editing images in Photoshop with the profile creation software packages, as mentioned in this chapter. The illustration shows X-Right Monaco's Pulse interface for profile editing. (For much more on editing profiles, see Chapter 5.)

Convert to Output Profile

Once you've gone to the trouble of establishing profiles, actually using them becomes one of the easiest stages to control in a color-managed workflow. In this final stage of the color-managed workflow, we'll put the output profiles to use.

Placing Color Profiles

When you create a profile for any of your devices using profile creation software, it is automatically saved into your system folder (the *ColorSync Profiles* folder on the Mac or the *Spool → Drivers → Color Folder* in Windows) and is ready to use by the applications or print drivers.

If you download a profile, you will need to place it in your system folder so that Photoshop or your print driver can use it. The directory for placing the profile in various operating systems is shown in the table to the right.

Operating system	Profile location
Windows 95/98	Windows → System → Color Folder
Windows 2000	WinNT → System 32 → Spool → Drivers → Color Folder
Windows XP	Windows → System 32 → Spool → Drivers → Color Folder
Vista	Windows → System 32 → Spool → Drivers → Color Folder
Mac OS 9	System Folder → ColorSync Profiles
Mac OSX	(Username or hard drive name) → Library → ColorSync → Profiles

Checking Your System Profile

Your monitor profile is your system profile, which is automatically saved to the profile folder when it's created and, in most cases, is seeded as your system profile automatically. There are two places to check to make sure that your profile is properly seated.

In Windows, right-click on your desktop to bring up the Display Properties, select the Settings tab, and then click the Advanced button. Select the Color Management tab, and you should see the name of your monitor profile selected. If you do not see it, click the Add button (which will take you to the *Color* folder), select your profile, and then click the "Set As Default" button.

On the Macintosh, open the System Preferences, select Displays, and select the Color screen to show the selected profile. If your profile is not highlighted, scroll through to find it, and select your monitor's profile.

Monitor profiles can also be selected in Photoshop. On either platform, from your Color Settings window, choose the RGB Working Space pull-down menu, and you should see your saved monitor profile name next to Monitor RGB. This will allow you to use your monitor profile as a working space, if necessary.

> Photoshop automatically uses your system profile to display your images accurately in Photoshop.

Occasionally, a monitor profile may become corrupted. When this happens, nearly everything looks fine except images viewed in Photoshop (because Photoshop uses the profile, as mentioned above). If this ever happens to you, you must find the profile in your *ColorSync* or *Color* folder, move it to the trash, empty the trash, restart your computer, and then recalibrate your monitor. This happens to me once or twice a year and is easy to fix by recalibrating.

Applying Profiles for Output

Applying profiles, or rather converting to a profile, for output can be done in any one of three places in a Photoshop workflow:

- **In Photoshop, Edit → "Convert to Profile"**

- **In Photoshop, File → "Print with Preview" interface**

- **In your printer's driver or File → Export plug-in interface**

Apply the profile with the same print settings that were used to create the profile.

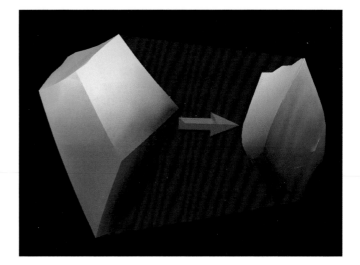

> If you are working with a professional photographic lab, the chances are good that you will not need to apply an output profile. However, you may need to apply one if your working color space is different from the lab's requirement. If this is the case, turn to the last section of this chapter, where I walk you through creating an action in Photoshop to prepare these image for your lab or printing press.

Using Photoshop's "Convert to Profile" command

From the main menu in Photoshop, select Edit → "Convert to Profile." In the Destination Space section, use the Profile pull-down menu to select your specific profile for printing, along with the conversion options. Select OK, and your file will be converted to the output profile. Visually, you'll see little difference in the image, but the values of the file itself will have been changed to print correctly. You are then ready to send the file to your printer with instructions to print in its

Convert to Profile

Source Space
Profile: Adobe RGB (1998)

Destination Space
Profile: 4800PLustET.icc

Conversion Options
Engine: Adobe (ACE)
Intent: Relative Colorimetric
☑ Use Black Point Compensation
☑ Use Dither
☐ Flatten Image

OK
Cancel
☑ Preview

Let Printer Determine Colors
Let Photoshop Determine Colors
Separations
✓ No Color Management

native, profiled form. Because you have converted your profile within Photoshop, Off or No Color Management should be selected in the printer driver and in the "Print with Preview" interface.

Using Photoshop's "Print with Preview" option

The second (preferred) method for converting to your output profile is by selecting File → "Print with Preview." This option is a little more convenient than previous one. In the Options area, select Let Photoshop Determine Colors, and choose your Printer Profile and your preferred Rendering Intent.

If you look to the right of "Let Photoshop Determine Colors," you'll see a little bubble with an exclamation point. By placing your cursor over that bubble, you can see the Reminder at the bottom of this window telling you to disable color management in the printer driver.

Using the printer driver to convert your profile

Start by clicking Print to bring up your printer driver. Choose your printer, if necessary. In Mac OS X, select Printer Color Management and then select Off (No Color Adjustment), thereby disabling color management in the printer driver. (Don't forget to use the Print Settings window to set your paper type and resolution.) In Windows, select the Main tab and then Advanced Settings to establish these same settings.

> If by chance you convert the profile and forget to turn off color management in the print driver, you will end up with some very interesting results that may not be to your satisfaction and that are not consistent.

Save your printer driver settings so that the next time you print using the same paper and profile, you can select saved driver settings without having to go through these steps each time.

As technology rapidly improves, one of the most powerful advances in ink-jet printing today is a technology developed by Canon: a new line of printers that use a 12-color pigment ink system, which includes not only the CMYK and light cmyk inks, but also red, green, and blue inks that allow for a wider color gamut. When installing the printer driver for the iPF5000 printer (or any of these printers), you have an option to install a driver plug-in to use in Photoshop or from Digital Photo Professional (Canon's image-processing software).

This plug-in supports another innovative feature for ink-jet printing: you can select a 16-bit printing mode that allows a powerful 12 bits of image data to be printed from a 16-bit file.

Using Auto Color for the output profile on the new Canons

I know this sounds a little iffy, but I can tell you from experience that this setting is very impressive because once you have selected the Media Type, the Auto Color chooses the correct profile automatically. Sure, you can always create and use custom ICC profiles and select them specifically, but the Auto feature works very well, and the custom profiles that I have built have been only as good as what comes with the printer.

To use this feature in Photoshop, choose File → Export → iPF5000 Print Plug-in to bring up the dialog box. You'll see Main and Page Setup tabs that you'll use to establish the initial settings for media type, printing resolution, orientation, and profile selection.

There is no need to convert to profile because selecting the Media Type and Auto (Color) will color manage the image automatically from the Main tab. Here, select the printing resolution and whether you want 8-bit or 16-bit. Also, if you click on the Set Configuration button, you can establish sharpening settings for your printing on the fly.

From the Page Setup window, establish your Media Size, Orientation, Layout information, and Media Source (such as cassette, roll paper, tray, or front load in). The Color Settings tab's (not shown) default settings are all set to zero and should remain so, regardless of whether you're using Auto or selecting a profile for printing.

When you return to this Canon plug-in, the settings will be the same as the last time you printed. So, unless you're using a different paper or media source, simply double-check your Orientation and print away.

If you prefer to use "Print with Preview," as described earlier, the same settings are available in the printer driver for the Canon printers (except for 16-bit printing). Select the Set option in Color Handling to have the option to select No Color Management.

Using a RIP software or hardware/software package offers many production advantages in a printing workflow, and there are a variety of software solutions available, including Colorburst, Onyx, and ScanVec. RIPs can be either hardware or software based, and they allow you to assemble a series of images, select the printer, prepare for package printing, change media type and profiles, and choose other settings outside of

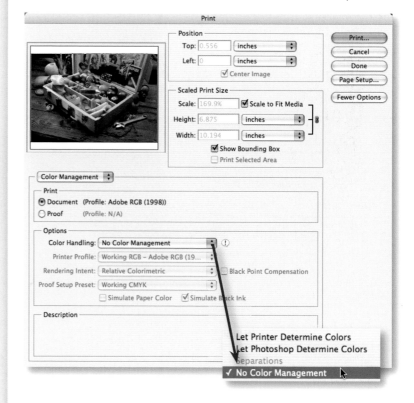

Photoshop. You can drag and drop image files to a work area for printing.

Printer	Calibration	ICC profile	ICC color control
Ink-jet - Canon 5000	Automatic	Custom and vendor supplied	RIP or print driver
Ink-jet - Epson 9800	Automatic	Custom and vendor supplied	RIP or print driver
Ink-jet - Epson 2200	Manual	Custom	RIP or print driver
Laser printer	Manual	Custom	RIP or print driver
Dye sub - Sony	Software	Custom	RIP or print driver

In-house printing

Printer	Calibration	ICC profile	ICC color control
Professional Photographic Lab	At lab	At lab	Send or convert to sRGB
Professional Photographic Lab 2	At lab	At lab	At lab
Consumer Lab - Costco	At lab	Download from Internet	Convert to their profile
Marathon Press	At plant	At plant	Send or convert to Adobe RGB (1998)
DynaColor Press	At plant	At plant	At plant
Unknown CMYK press	N/A	N/A	Embed Adobe RGB (1998)

Outsource printing

Output Objective Lists

One of the most useful things that you can do is make a list of all the output devices that are involved in your workflow. Include all of your output needs and uses: ink-jet, dye sub, professional photographic labs, consumer labs (e.g., Costco), full-color printing presses, news print, laser printer, Internet, and even unknown CMYK four-color printers. For each output objective, create a description of how each is managed from your workflow and create separate lists for in-house and outsource printing needs. Creating this list will remind you that each output objective may need certain workflow procurements or special attention. In addition, it will help you identify which stages of your workflow might be automated using actions or droplets (see next section).

Creating CM Workflow Actions

When it comes to a color-managed workflow, using actions in Photoshop is not only a real time saver, but also offers the means to assign a function key, process in batches, and create a droplet on your desktop to which you can drag-and-drop a folder of images for the output action.

The following steps describe how to create an action. I have defined four different actions for output in my workflow, including actions for images going to Lab A, Press A, Press B, and Lab Costco. When you record your actions, you will naturally want to use a similar approach for your output needs. (Note that these actions are for outsource printing rather than in-house.)

Before you start to record the action, go to your hard drive, select a directory, and create what I call a "hot folder" for your output, where you will place images to send to your lab.

At the bottom of the Actions Palette, click on the folder icon to create a new Action Set. Name it "Output Production" or any name that will define this set as your output workflow.

The first action is going to be for Lab A. In this example, my working space is set to Adobe RGB, and my RAW files are originally processed, retouched, and saved in ProPhoto RGB. My lab requires sRGB for printing. This action will simply convert the color space of the selected files into sRGB for my lab and save the file as a TIFF in the hot folder for Lab A.

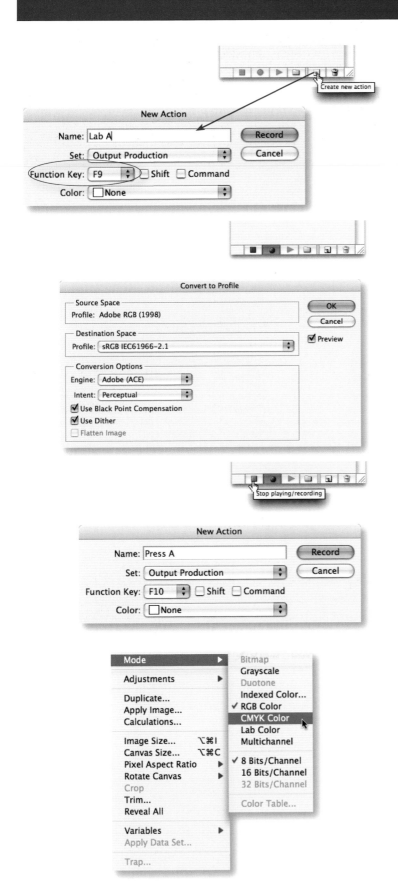

At the bottom of the Actions Palette, select the Create new action icon. Name this action Lab A, and assign a Function Key. This allows you to play the action by simply pressing a function key; here I'm using the F9 key.

Click Record, and notice the red circle at the bottom of the Actions Palette that lets you know that you are recording the action. To convert the file to sRGB, from the main menu, go to Edit → "Convert to Profile." In the Destination Space, choose sRGB. Next go to File → Save As. Here select the Lab A hot folder that you created. Do not name the file in this window, but select the format, such as TIFF or JPEG. Go ahead and save the file, and then at the bottom of the Actions Palette, click on the Stop Recording button to the left of the red circle. Your action is now ready for production.

Now, let's create an action for Press A. Let's say that Press A does not have an ICC profile. I have created a custom CMYK setup for conversions (in this case, you could select one of the CMYK defaults in Photoshop, but be certain to check with your printer first).

Once again, create a new action, but this time name it Press A. From the main menu, select Image → Mode → CMYK Color (the files will be converted to CMYK), and then select File → Save As. Select the Press A hot folder, save the file in the format needed, and then stop recording.

For Press B, which, let's say, does have an ICC profile, start to record, but rather than selecting Image → Mode → CMYK Color, use Edit → "Convert to Profile." Select the profile for the press, and as before, use File → Save As, save into the Press B hot folder, and stop recording.

> For Lab Costco, repeat the same steps, but choose the ICC profile that you have acquired for this lab, available at http://www.drycreekphoto.com/icc.

With this rather simple procedure, your Actions Palette will have actions for a variety of output scenarios.

Now that you have the actions, you can create droplets (literally, places to drop files into) that will reside on your desktop. You can simply drag a file or folder of images to a droplet in order to convert and save in the respective hot folders.

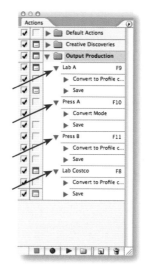

Create Droplet

Save Droplet In

(Choose...) Macintosh HD:Users:...:untitled folder:Lab 333

(OK)
(Cancel)

Play

Set: Output Production

Action: Lab A

☐ Override Action "Open" Commands
☐ Include All Subfolders
☐ Suppress File Open Options Dialogs
☑ Suppress Color Profile Warnings

Destination: Save and Close

(Choose...)
☐ Override Action "Save As" Commands

File Naming
Example: MyFile.gif

[Document Name ▼] + [extension ▼] +
[▼] + [▼] +
[▼] + [▼]

Starting serial#: [1]

Compatibility: ☐ Windows ☑ Mac OS ☐ Unix

Errors: Save As... [Stop For Errors ▼]

(Save As...)

To create a droplet, from the main menu, select File → Automate → Create Droplet. Click on the Choose button, and navigate to the location where you want your droplet—the desktop, for example. This is also where you name your droplet. Let's name this one *Lab A*.

In the Play area of the Create Droplet window, you must choose your Set and Action to play. Also, make sure to check Suppress Color Profile Warnings. Not checking this box will cause Photoshop to stop the action when it gets to opening the files from the droplet, giving you the Mismatch or Missing Profile warnings. In the Destination area, select Save and Close. Now you can click the OK button, and your droplet will be created.

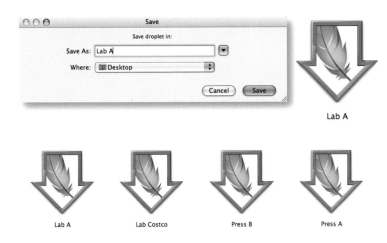

Save

Save droplet in:

Save As: [Lab A] [▼]
Where: [Desktop ▼]

(Cancel) (Save)

Lab A

Lab A Lab Costco Press B Press A

Create a droplet for each of your output actions. When you use the droplet, your original file(s) remains unchanged, but in your respective hot folders, you'll find a new saved file that has been converted to the color mode or profile for your printer. At this point, you can upload the hot folder to your lab or burn a CD or DVD to send to your lab.

Technically Speaking

Now that we've covered the basics of color management, it's time to turn to the expert for some technical supercharging. In this chapter, my own color managment guru, Rick Lucas, will share some of his expertise.

Contents

Chapter 5

Under the Hood

As we've already seen, color management can be a technical subject, truly understandable only by color scientists and color geeks. But a little advanced insight can be helpful for achieving true practical understanding. This chapter will review some of the earlier stuff, but with a more expert eye.

For the most part, the work that is done with color management is done under the hood. For many people, this is where it should stay. However, there are always a certain number of you who want to understand what is actually happening, and I don't blame you: the more you understand the whys and hows, the better your color, and the more likely you are to know what to do if something goes wrong.

As we've seen, in its simplest form, color management converts color between different devices to achieve predictable and repeatable color. So how is this done? As covered in previous chapters, color management consists of two steps: calibration and profiling.

A Closer Look at Profiles

So by now you understand that a profile is no more than the characterization of a device and how it sees, displays, or reproduces color. Profiles are broken down into various classes: display, input, output, color space conversion, abstract, named color, and device link.

We've already spent some time in this book with display, input, and output profiles, so they should be pretty familiar by now. Other profile classes that you may not be as familiar with are used for very specific purposes, and for the most part, you will not run into them as a photographer.

#	Tag	Data	Size	Description
	Header		128	
1	'cprt'	'text'	43	Copyright ASCII Text String
2	'desc'	'desc'	67	Localized description strings
3	'DevD'	'text'	57888	ASCII Text String
4	'CIED'	'text'	465866	ASCII Text String
5	'Pmtr'	'text'	836	ASCII Text String
6	'chad'	'sf32'	44	Chromatic adaptation matrix
7	'wtpt'	'XYZ '	20	Media white-point tristimulus
8	'kTRC'	'curv'	1034	Tone response curve
9	'A2B1'	'mft2'	95052	Intent-1, 16-bit, device to PCS conversion table
10	'B2A1'	'mft2'	132248	Intent-1, 16-bit, PCS to device conversion table
11	'A2B0'	'mft2'	95052	Intent-0, 16-bit, device to PCS conversion table
12	'B2A0'	'mft2'	132248	Intent-0, 16-bit, PCS to device conversion table
13	'A2B2'	'mft2'	95052	Intent-2, 16-bit, device to PCS conversion table
14	'B2A2'	'mft2'	132248	Intent-2, 16-bit, PCS to device conversion table
15	'gamt'	'mft2'	35414	16-bit, PCS to gamut check table
16	'gmps'	'data'	196	

Size:	1,148,588 bytes
Preferred CMM:	Apple
Specification Version:	2.4.0
Class:	Output
Space:	CMYK
PCS:	Lab
Created:	9/16/05 3:33:54 PM
Platform:	Apple
Flags:	Normal Quality
Device Manufacturer:	
Device Model:	
Device Attributes:	00000000 00000000
Rendering Intent:	Relative
PCS Illuminant:	0.96420, 1.00000, 0.82491
Creator:	'LOGO'
MD5 Signature:	

Profiles vary between very small (a 4K matrix-based profile of a monitor or color space) to very large (3MB for a very large table-based output profile). Each profile, no matter what the size, consists of a variety of data called tags and must conform to ICC specifications. The minimum number of tags that a profile may contain is four, which includes the name and the white point.

More complex profiles, such as a printer profile, include much more information, such as color tables for different rendering intents, both to the printer and back to the monitor for soft proofing, or for doing simulations of one device with another. If you are interested in going into the inner working of profiles further, there are numerous articles and books that go into great detail on the subject (see the Appendix for a list of our favorites).

Color Management Module (CMM)

As we noted in Chapter 2, the CMM is the part of the software that actually does the transformations, which involve considerable math. Both Windows and Mac operating systems include their own CMM as part of the operating system. For the most part, the two CMMs are identical, since they both were originally licensed from Linotype-Hell. CMMs are also available from other vendors, including Adobe, Logo, and X-Rite to name a few. In Photoshop, for instance, you have the option to pick your own CMM, and the default is the Adobe CMM. If you want to experiment, you can try picking a different CMM and see if there is any visual difference. Most of time, you will see either little or no difference. However, some images with different rendering intents may show greater differences when the CMM is changed.

Since the CMM does a mathematical transformation and the color tables in the ICC profile do not contain every point, the CMM has to interpolate the data. If profiles contained every point, they would be very large. How interpolation is handled is different for each vendor.

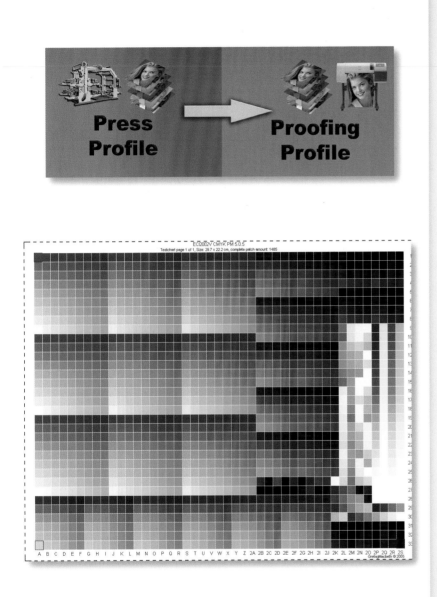

CMYK Proofing

The ICC-based color management system works reasonably well, but there are some limitations. One of the main limitations of ICC color management comes in preparing prepress proofs, especially when trying to match a printing press or contract proof. For prepress proofing, you are typically converting from CMYK to CMYK, and with ICC color management, the data does not convert as accurately as needed. There are a variety of digital-proofing RIPs (see "Raster Image Processors (RIPs)," later in this chapter) on the market, such as those by GMG and Dupont, that do not use ICC color management but instead use a four-dimensional table to overcome the limitations of ICC. These specialized proofing RIPs usually send a standard test target, such as the ECI 2002, which contain many patches of different CMYK combinations, to both the press and the proofing printer. Each of the four colors of the digital files is mapped directly to the CMYK of the output device. This type of transform is referred to as a four-dimensional table. It is nothing more than a large lookup table that provides a more accurate proof than can be obtained with an ICC workflow. The transfer is able to produce a more accurate proof because it converts from one profile to another by going through a profile connection space (PCS), such as CIE LAB, using a CMM.

These proofing RIPs are considerably more expensive than conventional RIPs and take a lot of work to set up.

Profile Editing

Profile editing is no more than changing an ICC profile if it doesn't work exactly the way you want it to. If you know how to use the various tools to correct images in Photoshop, then you should be able to edit profiles.

With a properly calibrated and profiled device, you should be able to achieve relatively accurate color. For most photographers, this workflow will work very well, and no further work will be needed. However, if you are more demanding or if you find limitations to the profile, then you may want to consider editing the profile.

> Some profiling software allows you to use different settings and options to achieve better color when creating the profile. Standalone editing software applications or modules, which allow you to edit a profile after it has been created, are also available.

Before editing a profile, however, you will need to print out a variety of different images to get an overall idea of how the profile is responding. Profile editing is not used to fix a specific image problem, but is instead used to fine-tune the profile for a variety of work. In other words, this kind of adjustment is used for fixing a whole category of images rather than a single one.

Profile-Editing Applications

Your first option is to change some of the settings in your profiling application itself. For instance, MonacoPROFILER gives you numerous options when you're actually

creating the profile. (Note that the settings that control color are available only for the perceptual rendering intent.) These controls are fairly limited and are global controls as opposed to selective controls.

The main way of editing a profile is with a standalone profile editor, such as GretagMabeth's ProfileEditor. There are other profile-editing software applications on the market. Each has its own unique way of editing, but if you understand editing color within Photoshop, you should not have any difficulty with any of them. This software will edit input, monitor, and output profiles, even those created by other ICC-profiling applications. Let's take a look at editing a profile in ProfileEditor.

You can edit a profile by itself or in combination with other profiles. Even if you are editing just one profile, it is generally recommended that you select both the source and destination profiles, as shown in the figure, and then edit the one you want.

For this example, we'll edit Pro4000 Photo Qlty IJP, an RGB profile. For this example, we used *AdobeRGB1998.icc* as the source profile because many photographers use it as their standard RGB working space. Before editing the printer profile, you need to pick the rendering intent that you wish to edit, which in this example is Perceptual. You also need to have your monitor calibrated and profiled because the editor uses this as the System Profile. This System Profile allows you to preview a standard test image that you are going to edit. Select the file using Open Image. This image should be in the same color space as your source profile. It's important

that your standard test image is accurate; you should probably use a commercially available test image, such as the DIMA test image.

Once you have selected the printer profile, there are many tools that you can use to edit it. The tools are laid out from top to bottom in the order that they should be used, although you don't have to use them all. The first tool that we'll use in this example is the Gradations tool, which you can use to fix the overall tonality (lighter, darker, contrast, etc.) by moving all the curves at once. You may also edit each curve individually to fix an overall color-balance problem or color problems anywhere on the tonal scale.

If you know how to edit curves in Photoshop, you should have no difficulty using the Gradations tool within ProfileEditor. When you make changes to the curve, the sample image will change also. On the top and left side of the image window, there are two sliders that can be moved so that you can see the effect of the profile both before and after the edit. Also, as you edit the image, you can view the numerical readouts (Values) of a specific point within the image by selecting the eyedropper at the top of the image window and clicking the area of the image for which you wish to see the numbers. A small color box visually shows the before and after. (The Values are affected by all of the tools.)

Another very useful tool is Global Correction, which allows you to adjust the overall Lightness, Contrast, and Saturation of the image.

The Selective Color tool is very powerful. Selective Color allows you to adjust a very specific color or small range of colors

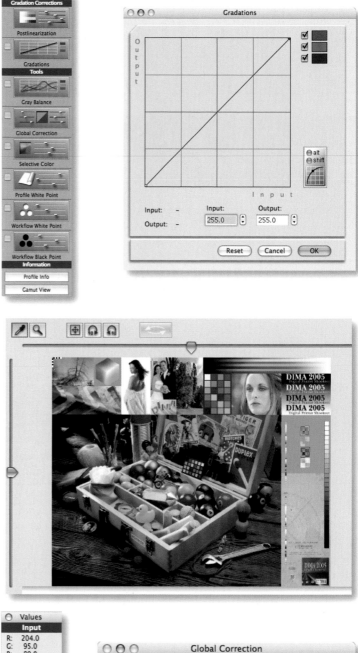

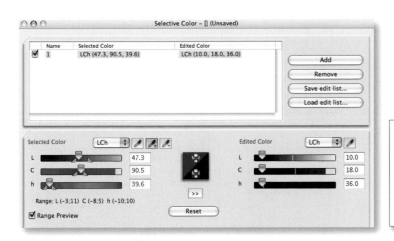

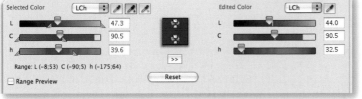

without affecting other colors. Let's say you have a certain red that, even with a profile, appears to be too orange and light. To fix this problem, you need to remove some of the yellow from the red and darken it. The first step is to open the Selective Color tool. This tool allows you to make multiple selective color edits, but for this example, you are going to make just one red edit. Click on the Add button to create the first edit. Next, click on the leftmost eyedropper and select the red color in the image that you wish to edit. The first selection will be a very narrow range of color, but you have the ability to add to the selection by either moving the sliders or using the plus eyedropper. If you pick too much color, you can use the minus eyedropper.

> You can edit an image in the color spaces LCH and LAB. LCH is probably a more intuitive color space with which to work; L is the lightness, C is chroma (saturation), and h is hue (color).

By selecting the Range Preview box, you can show the range of colors that you wish to edit in green. If you turn off the Range Preview, then you will see the image without showing the range, even though you have selected it.

Once you have picked the color (Selected Color) that you want to edit on the left side, you will then transfer this color to the Edited Color side by clicking on the double-right arrows (>>). From this point on, you will adjust the new color by either using the LCh sliders or changing the numerical values. In our example, to darken the red slightly and take a little yellow out, the L was lowered a bit and

the h was moved a little from the yellow. The sample image in the window reflects this change.

Once you have made all the edits to the profile, you will need to save it. When saving the profile, you can save only for the device and rendering intent that you initially selected, for different rendering intents, or for soft proofing. Naming conventions are important, so my recommendation here is to use the original name of the profile and add E1 to to indicate Edit 1.

Because you may have to do several edits to a profile after printing to see how the edit actually performs, you can then name the next profile E2, and so on. Note that it is best to print a variety of test images with the edited profile because one image may not be representative.

In this example, we used output device and single rendering intent only. While this doesn't cover all of the different options, it should give you a preliminary introduction to profile editing.

Input profiles from scanners and digital cameras may also be edited with ProfileEditor or other profile-editing software.

ProfileEditor **File** Edit Tools Window Help

New ⌘N
Close ⌘W
Save As... ▶ | ICC Profile...
Gray ICC Profile...
Load Edits... | Photoshop Table...
Save Edits...

Save Profile

Decide if you wish to save the edits into other rendering intents and for the other profile direction. Then click the Save As button.

○ Easy Mode
⦿ Manual Mode

Lab -> RGB (B2A):
☑ Perceptual
☐ Relative / Absolute
☐ Saturation

RGB -> Lab (A2B):
☐ Perceptual
☐ Relative / Absolute
☐ Saturation

To apply the edits to the soft proof portion of the profile choose ALL the rendering intents on the right. To apply the edits to the output portion of the profile choose the rendering intents on the left. The intent based upon your edits is preselected.

☑ Write file name into desc-tag

desc-tag: file name

Cancel Save As...

○○○ Save ICC profile...

Save As: Pro4000 Photo Qlty IJP E1.icc

Where: Profiles

Cancel Save

Many of you will do just fine with the scanning information presented in the previous chapters, but here we will go into much greater detail for those of you who need (or just want) it.

CM and Scanning: In Depth

First, remember that the general rule of thumb is that the better the original image or scan, the better the quality of the output.

> If you understand how to calibrate and profile a scanner, you are most of the way toward doing the same with a digital camera.

In this example, I will use the Epson Scan software with a Perfection 3200 scanner. Most other software works in a similar fashion; if you understand the concepts here, then you should be able to adapt them to your particular scanner. (Note that there are a few scanners, including the entire HP line, which are designed for the beginner or business user, which do not give you the controls to create a high-quality scan.)

So let's dig right in and set up the scanner. By default, the scanning software is in Full Auto Mode. There are a variety of options that are available if you go into the Customize options, including the type of original, the resolution of the desired output, dust removal and color restoration, and a few other features. Next to the Scan button (and not very obvious in our example) is the File Save Setting button, which allows you to select the location, file format, and name of your file.

The Home Mode is the next mode on the list, and it is a bit more advanced. Home Mode gives you considerably more options, including the Document Type that you are scanning. You are also asked for the Destination Document Type and the Output Resolution. The Configuration button at the bottom of the window brings us to a new window.

Finally, we are getting to the good color stuff. From the Configuration screen, click on the Color button, and you are presented with three options. Under the first option, Color Control, uncheck "Continuous auto exposure." If you leave this option on, the scanning software will take the lightest tone and make it pure white and take the darkest tone and make it pure black, which is a problem because we'll lose all the details in the highlights and shadows. Set the Display Gamma to the gamma that you have your monitor calibrated and profiled to.

The next option in the Configuration window is ColorSync on the Mac and ICM on the PC. This option allows you to apply a scanner profile to the scan and then convert it directly to your working space or, if you are not planning on editing the image at all, to apply the printer profile. For the most part, I would not use this setting, even though it looks cool, because it doesn't allow you to calibrate the scanner.

Last but not least, the third option is the No Color Correction option. This option would be used if you were planning either to apply your scanner profile or color correct your image in a program such as Photoshop. To obtain the best-quality scan with this option, it is best to scan at a high bit level.

Professional Mode is the third and most powerful scanning mode for the Epson Scan software. This is the mode where we're going spend the most amount of time, going through the many controls and options. As with the two previous scanning modes, we first need to determine whether we are working with reflective or transparent media. To scan transparent media, such as film, you either need a dedicated film scanner or a flatbed scanner that has a separate light source for the film.

In Professional Mode, we have an even greater number of options for Destination /Image Type. The two that we are most concerned with here are 48-bit Color and 16-bit Gray Scale. Earlier in the book, we spoke about the advantages of working with files with a higher bit depth. The concept of 48-bit color is a bit confusing until you realize that a 48-bit image contains three 16-bit files: one each for red, green, and blue (hence, 16 x 3 = 48-bit). Unless you are doing high production scanning with minimal to no corrections or enhancements in image-editing software such as Photoshop, you should scan at the high bit level, which will allow you to have the most tonal information with which to edit. After editing, you can convert the image into an 8-bit file.

The Adjustments give you a variety of options in the Reflective Mode, such as Unsharp Mask Filter and Descreening Filter. If we change over to the Film Mode, new options become available, including Grain Reduction, Color Restoration, and Dust Removal. Since our main concern is achieving the best color from the scanner, we won't go into detail about these options. If you need to find out more, see the Appendix for a list of books and

manuals that cover some of options more thoroughly than we can here.

Our foremost concern is the Adjustments indicated by the four icons at the top of the window. In order to make these options available, you need to be in Color Control Configuration. If they are grayed out, then you have selected either the ColorSync or No Color Correction options.

The leftmost icon is for Auto Exposure, which we don't want to use because, as mentioned earlier in this chapter, it blows out the highlights and plugs the shadows. The second icon from the left is the Histogram Adjustment, which is where we will do the most work in calibrating the scanner. We'll also be using the next two buttons in part: Tone Correction and Image Adjustment.

A great tool that we can use to assist us in calibrating the scanner for reflective originals is the GretagMacbeth ColorChecker. This target has been around for many years, and the reason that it works so well is that there are a limited number of patches (compared to other targets), and it is easy to find out what the RGB values of the patches are.

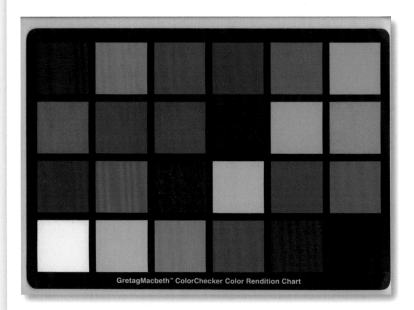

GretagMacbeth™ ColorChecker Color Rendition Chart

107 82 69	182 148 130	102 122 156	96 107 69	128 126 172	128 187 170
198 122 52	77 92 163	175 87 99	83 61 103	166 186 75	209 158 57
52 63 152	98 147 77	155 45 58	225 196 55	167 82 145	61 133 164
244 243 239	200 200 200	159 159 159	121 121 121	83 83 83	54 54 54

The values in this chart are for the Adobe RGB (1998) color space because most photographers will use it as their default color space. By reading the RGB values of the ColorChecker in the scanning software and adjusting them to those in the Adobe RGB chart, we can calibrate the scanner.

The Histogram Adjustment window gives you a tremendous amount of control over the scanner. We will use this window to set the highlight, shadow, overall tonality, and overall color balance using the ColorChecker. A histogram is a representation of the number of pixels at any given point on the tonal scale. Black is on the left, while white is on the right. The value of black is 0, while white is 255. For our individual RGB channels, 0 is no color, while 255 is the pure color.

If you work in other color spaces, a great resource of values for other color spaces can be found at http://www. brucelindbloom.com. Click on the Calc button and then on "ColorChecker RGB Summaries, Spreadsheets and Lab TIFF File." For those of you who have color geek tendencies, there is a lot of other cool information on this site.

In the Histogram Adjustment window underneath the histogram, you will find a series of sliders for both input and output. The Input scale has white, gray, and black sliders; three eyedroppers for white, gray, and black; and a numerical readout for each. The output scale is much simpler, with only white and black sliders and readouts. By using these tools, you can go a long way toward calibrating your scanner.

Let's go step by step:

1. Read the RGB values of the white patch of the ColorChecker. You'll notice that R is 248, G is 245, and B is 237.

2. Read the RGB values for the black patch of the ColorChecker (R = 35, G = 38, and B = 36).

3. Read the RGB values of the medium light-gray patch (R = 138, G = 142, and B = 138).

4. Compare the values obtained from steps 1 and 2 to values in the Adobe RGB (1998) chart. Our white values are high, our black values are low, and our gray values are low. This indicates that, by default, the scanner is contrasty and dark. However, notice that the RGB values are relatively close to one another, which indicates that the scanner is fairly neutral. Over the years, I've worked with some scanners that were much worse than this and that had all sorts of color-balance problems. Overall, scanning software has gotten much better in recent years and is less of a battle to calibrate.

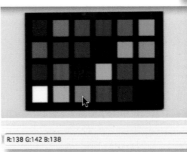

5. Since the target is dark overall, let's move the middle slider to the left until the RGB values of the medium light-gray patch are close to the desired 159 of the ColorChecker chart. Don't worry if the values aren't exact. Two or three points make it close enough. Also, the numbers at the bottom of the screen may jump around a bit, but try to find an average value.

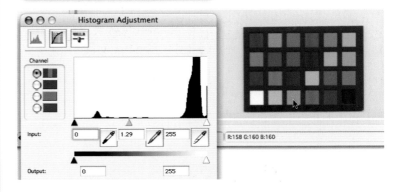

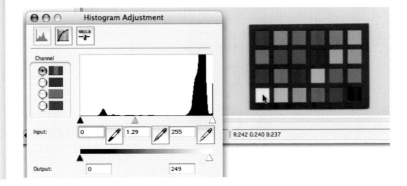

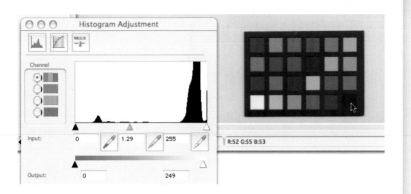

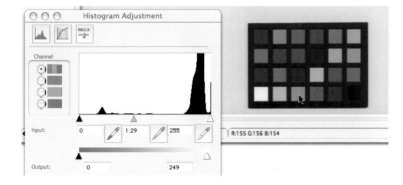

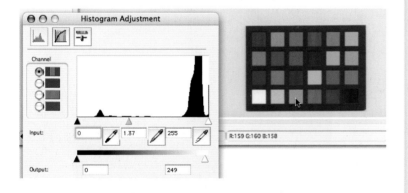

6. The next point to adjust is the white value to around 242. You'll notice the values on the ColorChecker are not equal to each other, which is because the material used to make this patch was not totally neutral. The blue value sits 5 to 6 points lower than the red and green. To make this adjustment, we should move the white slider on the output a little to the left.

7. The black point needs to be adjusted next. The desired value is 54, and in this case, no adjustment is necessary because we have the right numbers. Usually, this doesn't happen; in most cases, you will probably need to make an adjustment.

8. Next, we need to go back and check our medium light-gray patch again because it may have been affected by the other adjustments that we just made. You can see the values have shifted a little bit, so we need to move the gray input slider a little further to the left until the values are close to the desired 159.

9. Because our values are so close, we do not need to do any further adjustment. To make sure that you use the same calibration for future reflective scans, you should now save your settings. Saving your work will allow you to use it again. Unfortunately, the Epson software just gives us the name "Setting" and puts a sequential number behind it. Some other scanning software allows you to save these settings with a more descriptive name.

Raster Image Processors (RIPs)

A RIP is a device or software application that allows you to output files to a printer. RIPs are used to drive a variety of devices, including laser printers, presses, and film and plate setters, but we are going to focus primarily on ink-jet printers because photographers use them most often.

RIP stands for Raster Image Processor; *raster* refers to a continuous tone bitmapped image, made up of dots like a photograph. RIPs are expensive and require a lot of time to set up, but that can be more than offset by the productivity gains and more accurate control of color. For the amateur photographer on a tight budget, a RIP may not be necessary, but for a professional photographer who is looking to produce accurate color on different types of nonstandard media or is producing a large volume of work, a RIP may be required.

For many people, using the standard Windows or Macintosh print driver works perfectly well. So why would we want to use a RIP? The two main advantages are productivity and control. For those who need to print PostScript files, a PostScript RIP is absolutely necessary.

First, let's discuss the productivity advantage. Productivity can be increased by letting a separate RIP print to the printer, freeing up the printer driver from having to process the file. In most cases, this does not speed up printing if the software RIP is on the same computer that you are printing from. The speed advantage comes when you put the RIP software on another computer or use a separate hardware RIP. This spares the local computer from processing and printing the file.

RIP features	Benefit
Nesting	Automatically group images
Previewing	See an image in RIP software
Color correcting	Color correct image without reprocessing
Image placement	Manually place image layout
Reading and applying profiles	Read embedded profiles and apply printer profile when printing
Calibration	Control of inks to bring to known and repeatable state
Queues	Folder with a specific set of parameters
Step and repeat	Ability to print multiple times
Scaling and rotating	Resize image and rotate
Tiling	Print large image over multiple smaller sections
Simulation	Make a device simulate another device
Pantone and custom colors	Ability to accurately print Pantone and user-defied colors
Color management	Use profiles to obtain accurate color

Hardware or Software RIPs?

RIPs come in two flavors, software and hardware. Software RIPs are installed on your own computer, while hardware RIPs are installed either in the printer, as for some of the HP printers, or are standalone, such as the Fiery RIP. Hardware RIPs have the advantage of being Plug and Play and work relatively well. The disadvantage of hardware RIPs is that they cannot be updated. Software RIPs, such as Onyx, have the advantage of being less expensive, having more controls, and being upgradeable.

The Right RIP for You?

There are a wide variety of RIPs on the market with different feature sets and price ranges. Currently, the majority of RIPs are on the PC platform, but there are numerous RIPs for the Mac also. Listed in the table at left are some of the major features of a RIP. Note that not every RIP has all these features.

First, you need to ask yourself, "Do I need a RIP at all?" As just mentioned, using a RIP is about productivity and control. My recommendation is to start with the normal print driver and see if it works for you. You may find that the color and productivity are adequate for your needs. But if you work with nonstandard media, want better color, or need greater productivity, consider using a RIP.

Let's look at the color issue. The manufacturers of ink-jet printers have done a fairly good job of getting decent color from their printers using their standard media and inks. With a good RIP, you can control color even better, and one may be necessary when you're using custom ink or media.

RIP and Printer Calibration

To obtain optimum color, first you need to calibrate the printer. Calibration of an ink-jet printer involves three major steps: ink restriction, tone distribution, and overall ink limiting.

Ink restriction

The first calibration step is to restrict the amount of ink being applied to the paper, a process that is conveniently called *ink restriction*. In extreme cases in which there is too much ink on the substrate, ink may drip and run. To avoid this, ink restrictions can be applied for each primary ink color (CMYK) separately. Some printers use multiple inks for each color, such as cyan and light cyan, and the ink can be restricted for both the dark and light ink. A general rule of thumb is the higher the print resolution, the more the ink needs to be cut back because the print heads are moving more slowly. On the other hand, if you decide to print at a lower resolution, less ink needs to be cut back because the heads are moving much more quickly. Another reason for ink restriction is to control the amount of hue error that results from too much ink being applied to specific media. For some combinations of printers and media, if you put down too much ink, you'll actually get color shifts. Cyan and magenta inks tend to shift the most, while yellow is relatively pure and may only shift a little. Too much black will tend to fill up the shadows.

So how much do we restrict the ink? If we limit the ink too much, then we limit the gamut of the device. If we don't limit enough, we get hue errors that result in compressed tones. These hue errors can be mostly corrected for with ICC profiles, but that method will not achieve

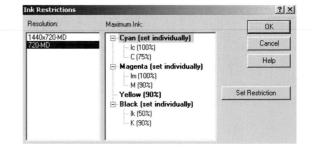

optimum results, and that's the point here. With practice and experience, we can manually determine the proper ink restriction for a specific combination of ink and media.

> The advantages of using multiple inks (light and dark) for one color are smoother tones and less apparent grain.

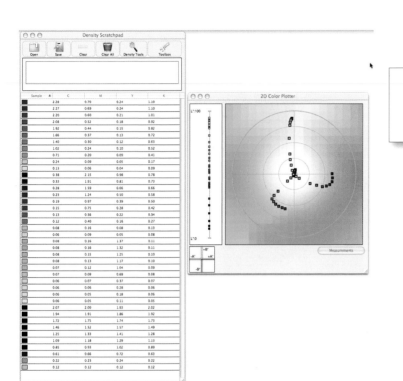

Ink restriction can be done visually, but a better and more efficient way to determine ink restriction is by using a combination of software and hardware, where you can measure the ink with hardware and then use this data in software to assist you. One excellent software tool that can help you to accomplish this is Colorshop X from X-Rite, which allows you to visually plot the hues (colors) of your individual colorants (CMYK) and helps determine the maximum amount of ink you can apply and still minimize hue errors.

To the left are two examples of plotting the hue angles, one bad (top) and one good (bottom). Both figures show the three primary printing colors—cyan, magenta, and yellow—in 10 percent increments, from 100 percent on the outside to 0 percent on the inside. In the first figure, with no ink restrictions at all, the cyan and magenta show major color (hue) changes as the amount of ink is increased. The yellow and black do not show these hue shifts. In the figure on the bottom, the ink was restricted considerably. Notice that both the cyan and magenta show much less of a hue shift than they did with no restriction. Some hue shift is tolerable because it can be corrected in the ICC profile. If the ink

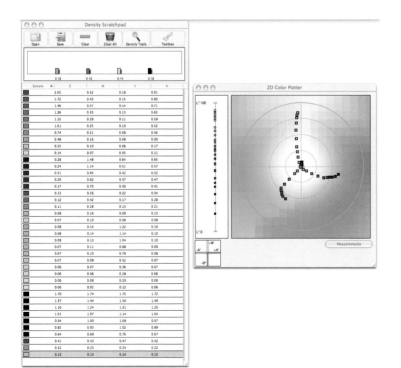

is restricted too much, you will restrict the gamut of the device too much, and you will be unable to achieve a wide color gamut. If you are working with Pantone colors, for instance, it is important to not restrict the ink too much. Restricting ink requires a compromise between gamut and hue shift.

Also, notice the boxes going down the black line in both figures. This line represents the neutral axis and determines the neutrality of the grays. When the hues angles are distorted, it is difficult to achieve a good gray balance. But with good ink restriction, you are able to control the hue shifts and also achieve better neutrals.

Tone distribution

The second step of calibration is to distribute the tones so that you can see a full range of values from dark to light, which is called *linearization* or, as some call it, *calibration*. As we discussed in previous chapters, calibration is a term that is often misunderstood. Technically, calibration is bringing a device or output into a consistent and repeatable state, which often involves multiple steps. Calibration is done by printing a series of CMYK patches to the printer and then measuring the patches. The RIP software then distributes these tones so that you can see the whole tonal scale with even steps in-between for each color.

Ink limiting

The third and final calibration step is ink limiting, which is similar to ink restriction in that you are cutting back the ink. The difference with ink limiting is that you are cutting back combinations of inks. For instance, red is a secondary color, being a combination of magenta and

OK

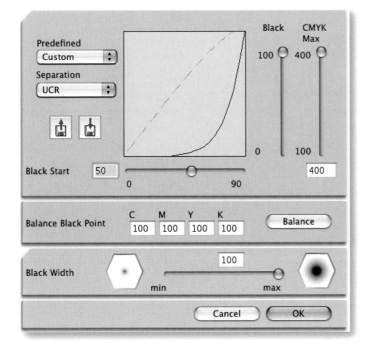

yellow, and this combination can be limited separately. Green and blue are also secondary colors and can be limited independently of primary colors. In addition to these three secondary colors, you can also limit combinations of three and four inks. Some RIPs offer this feature, while other do not.

Creating an ICC Profile

Once you have achieved good calibration, creating the ICC profile is much easier. To create a profile of a device, use profiling software (such as ProfileMaker) to send the device a series of color patches. In Chapter 4, we covered the same thing, except now we're going to send a CMYK target instead of an RGB target. Remember that the standard print driver does the conversion from RGB to CMYK for the printer. Almost all RIPs allow you to control directly the CMYK inks of the printer. Read the patches with a spectrophotometer, and create a CMYK profile. In most profile software packages, you'll have a variety of different options to control how the profile is made.

Due to the nature of ink-jet printers, accurately controlling the generation of black is crucial to creating good profiles. If a printer has only one black ink and it is introduced too early, you'll get an effect called peppering, apparent in the light to middle tones. If you use GCR (Gray Component Replacement), black is introduced too early. UCR (Under Color Removal), on the other hand, introduces black later on. So using UCR is preferred when creating profiles for ink-jet printers with a single black. To reduce peppering,

we don't want to introduce black until at least 50 percent. It may take some experimentation to find the optimum settings for creating a good profile.

> For printers that have multiple blacks of varying densities, peppering is usually not a problem, and you can use a normal GCR black generation. You still may need to experiment with where to start the black and how heavy it should be.

As we covered in Chapter 4, the real test for checking the calibration and profile of a device is printing several standard test images. A variety of standard test images work well for this purpose. You can go to Eddie's website (*www.eddietapp.com*; select the E:Technique button) to download some different test images that are in the Adobe RGB (1998) color space. Be sure to use this color space as your embedded profile when printing one of these test images. If you have a good test image of your own, you can also use that. When printing a test image, be sure to print from the same application that you print from regularly, and be sure to use the proper calibration and profile you created previously. Because we normally print through the RIP, it would be the best place to apply the profile.

Evaluate the image after it is printed. Look for neutral grays, good shadow detail, natural flesh tones, smooth transitions in saturated colors, and so on. If you have created a good calibration and profile, the image should look very good. If the image does not look good, you may need to create a new calibration for your printer or create a new profile with different settings. If the image you printed

Placement Strategy

General | Options

☑ Print Multiple Rows at a Time

☑ Horizontal Copying

Contour Cutting:
None

Space Between Copies: 0.02"

☑ Grouping:
⦿ By Tiles ○ By Copies

☐ Rearrange Tiles to Conserve Media

Cutter Mark Darkness
1 2 3 4

ICC Profile Setup

Profiles | Rendering Intents | Output

CMYK Image TR004.icc

CMYK Vector TR004.icc

RGB Image aRGB(Gamma22).icm

RGB Vector aRGB(Gamma22).icm

Custom Image No Profile Selected

☑ Use Embedded Profile When Available

Proof Dupont Water Proof.icm

looks good but just needs some minor adjustments, it would be best to go back and edit the profile slightly (see the earlier section in this chapter, "Profile Editing").

Productivity Controls with RIPs

Now that we've looked in detail at the color controls that are available in a good RIP, we're going to discuss some of the productivity advantages of using a RIP. One large advantage of using a RIP is speed, both for processing the files and printing. Offloading the printing to another computer frees up your own computer. Having the RIP on another computer allows you to share the printer over a network. When sharing a printer over a network, you can set up a variety of queues, each of which can be configured with different parameters, such as different media or sizes.

Another great feature of a RIP is nesting, which allows you to use paper more efficiently. Different RIPs may use different terminology for this feature. The RIP shown at left is the Onyx RIP. For example, say that you have a bunch of 8 x 10 images that you would like to print to a 36-inch printer. You can either manually place the images across the sheet to minimize waste, or you can set up nesting, which will automatically place the images for you, saving a lot of time and intervention.

Another feature that some RIPs have is the ability to simulate another device, which is useful if you're trying, for instance, to simulate another device, that has a smaller gamut than your printer. Using this feature requires a profile for both your printer and the device that you are trying to simulate.

RIPs also allow you to print Pantone and spot color accurately. The RIP offers a series of LAB numbers for each of the Pantone colors. These values are then converted using the printer profile so that the color is printed correctly. In order for the RIP to see these Pantone colors, they must be sent as a postscript file (PS, EPS, PDF); the Pantone colors come over as named colors, and the RIP picks up these names. The RIP will also allow you to create you own custom spot color, which is useful when you have a client who is trying to match a logo color.

In addition to automating the workflow, some RIPs allow you to edit images at the RIP workstation, including color correction of an image after it has been ripped and printed. This feature is used to fine-tune an image and saves time, but it should not be used to fix poor original images or bad profiles. "Step and repeat" is a great tool for printing multiple copies of the same image without having to place the same image over and over again. Image sizing and rotating are self-explanatory. Tiling is a great tool if you are trying to place an image that is larger than the media size and needs to be spread over multiple sheets or rolls. With tiling, you are also able to control things such as overlap and where the image will break.

As we've seen, whether you're using a software or hardware version, a RIP can assist you in better controlling your output and increasing your productivity. The marketplace offers many different RIPs. You can decide on one by assessing your needs, skill level, budget, and so on. At this point, you should be better able to determine if you need a RIP and, if so, what features you want.

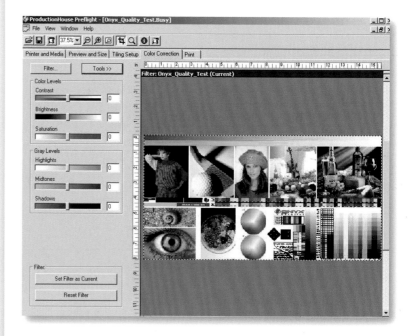

As we've seen already, calibrating and profiling a monitor is an absolute necessity for sound color management. Although calibrating and profiling can be done visually, it is much more accurate and consistent to use a hardware-measuring device with the appropriate software.

Hands-On Monitor Profiling

Although we've covered it in general in Chapter 4, let's go through the specific steps for calibrating a monitor with a monitor-profiling package. There are numerous monitor-profiling software packages and measuring instruments available to accomplish this task. Some, such as the Eye-One Display from GretagMacbeth and the Monaco Optix XR from X-Rite, come as a bundle. Others, such as basICCcolor Display, are just software and require you to purchase your own instrument. In this section, we are going to look at the Spyder 2 Pro from Colorvision solution using their hardware and software. Again, as with the other calibration and profiling sections in this part of the book, don't get bogged down with the specific interface of this software. Instead, it is important to understand the general concepts.

The cost of some monitor-profiling packages is now under $100.

As discussed in Chapter 4, before you calibrate the monitor, you need to make sure that it has been on for a least an hour to stabilize. Ideally, you also want to have the monitor in a room without outside light or overhead light. A monitor hood will help keep stray light off the monitor.

With these conditions met, let's begin the actual process. After launching the software, start by setting your preferences. Pick the sensor you are going to use and how often you wish to recalibrate the monitor. In this example, we are going to calibrate and profile an Apple Cinema Display, which is a LCD monitor, and we are going to have the software automatically remind us to recalibrate after a month (which we would never forget, of course).

Now let's pick the type of monitor we wish to calibrate—LCD, in this case. Moving forward, we need to select the white point and gamma, which is done in one step with this software. You'll notice that I picked 2.2 gamma and a native white point. It has been my experience that using the native white point usually results in a better monitor profile for a LCD than picking 6500K does. Still, it's a personal preference.

In addition to picking the white point and gamma, it is important to set the monitor to the proper luminance or brightness level, especially if you wish to set multiple monitors to match each other as closely as possible. This software allows us to set the luminance either Visually or Measured, and I recommend setting it as Measured to achieve more consistent results. My recommendation for LCD monitors is to set the White Luminance to 120, and for CRT monitors to 100. Because we have no control over contrast with the Apple Cinema Display, we are going to leave the Black Luminance blank.

This next window is a summary of the settings so far. Check and make sure everything is set correctly.

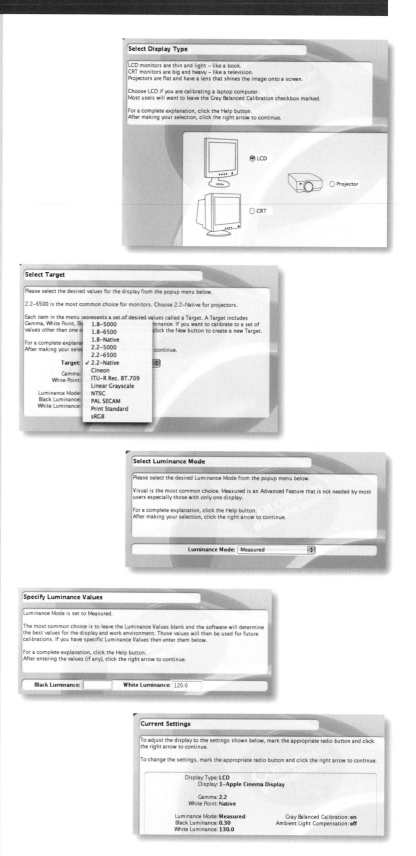

Place the sensor on the screen as shown. Suspend the device from the top of the screen. Do not use suction cups on LCD. When the instrument is positioned, click Continue.

Continue
Cancel

press esc to cancel

Reading red samples.

Continue
Cancel

press esc to cancel

Adjust the Backlight control until the current value matches the target value. Click Update to take a new reading after adjustment. When done, click Continue.

Continue
Cancel
Update

Target: 130.0 cd/m^2
Current: 158.2 cd/m^2

press esc to cancel

Apple Cinema Display

Show All

Display Color Options

Resolutions:
800 x 600 (stretched)
1024 x 640
1024 x 768
1024 x 768 (stretched)
1280 x 800
1280 x 960
1344 x 840
1344 x 1008
1600 x 1000
1680 x 1050

Colors: Millions
Refresh Rate: n/a

Detect Displays

Rotate: Standard
☑ Show displays in menu bar

Brightness

Adjust the Backlight control until the current value matches the target value. Click Update to take a new reading after adjustment. When done, click Continue.

Target: 130.0 cd/m^2
Current: 130.3 cd/m^2

press esc to cancel

As you may have noticed, the software does an excellent job of walking you through the process with many explanations and diagrams. To properly set the luminance of this particular monitor, we are prompted as to the type of controls that the monitor uses. The Apple Cinema Display uses a backlight control.

Next, we are going to place our sensor on the monitor, as the illustration indicates. Warning!!! These sensors have suction cups on them, so be careful not to push the sensor on the LCD screen because the suction cup can damage it. Use the suction cup on CRT monitors only.

As we've noted, profiling the monitor is a two-step process. First, we calibrate, and then we profile. With the sensor now on the screen, the software sends a series of color patches to the screen that the sensor feeds into the software.

We are next shown the actual luminance of the monitor compared with the value that we are trying to achieve. In this case, the actual value is too high, so we need to turn down the backlit display brightness close to our target of 130. With the Cinema Display, we can reduce the backlighting by using the Brightness slider in the Displays control in the Mac's System Preferences. By reducing the brightness some, we can adjust the current value very close to the target value. (Don't worry if the numbers are a little different.) At this point, we have finished calibrating the monitor.

The next step is to actually create the ICC monitor profile. The software will send a series of different color patches to the monitor and at the end will prompt us to name and save the profile.

The software creates the monitor profile by comparing the color values of the patches displayed on the screen to the color values as measured by the sensor on the monitor and then makes an appropriate adjustment to display color accurately. At the end, this particular software application allows us to preview the monitor profile that we just created and compare it to what it looked like before the calibration. The first time you calibrate your monitor, the difference can be quite dramatic!

Specify Profile Name

The display profile will now be created. This file will be stored in the system to be used by applications that check the characteristics of the display. This file will also be used at system startup to restore the calibration data to the video card.

Below is the suggested name for the display profile. You may modify it if desired.

For a complete explanation, click the Help button.
After making any changes, click the right arrow to continue.

Profile Name: Apple Cinema Display Spyder2

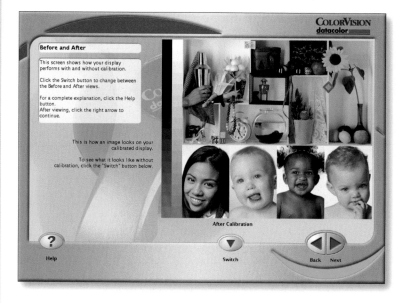

As you must realize by now, to achieve the best-quality output, you must be sure that the printer is consistent and that you use an ICC profile. In Chapter 4, we discussed the general profiling of a printer. In this section, we'll go through the hands-on steps to make that happen.

Hands-On Printer Profiling

Although some printers do not require calibration and some manufacturers supply excellent profiles for their printers, many printers do require calibration and need for you to create your own profiles to achieve the best results. These things are especially important if you use nonstandard media. There are many different color printers on the market, but the kind that almost all photographers use, because of both cost and quality, is the color ink-jet printer. For this reason, the printer that we are going to use for the examples in this section is the Epson 4800 ink-jet printer.

The Epson printer that we're using contains eight inks. Like many other ink-jet printers from other companies, it uses the standard four color inks—cyan, magneta, yellow, and black (CMYK)—that you need to make a color print. However, a few years back, the manufacturers realized that they could improve the quality of the printers by adding additional inks. They started by adding light inks—light cyan and light magenta. Adding these light inks improved the image quality, especially for photographic images, by reducing the graininess and improving the transitions of tones from dark to light. Then, light black and light yellow were added by some manufacturers for the same reason. Epson did not add light yellow, but in the 4800, they added a third very light black to

improve black and white printing and also to reduce the amount of bronzing.

The first step in calibrating and profiling the Epson 4800 printer is to realize that its standard printer driver does not have a method for calibrating, as was mentioned earlier. If you want to calibrate this printer see "Raster Image Processors (RIPs)," earlier in this chapter.

Before we send our first print to the printer, we need to discuss the paper. Every printer manufacturer sells its own brand of paper that has been optimized to work best with its inks. However, a large number of third-party papers are available for these printers. Some of these papers are excellent, while others can be quite poor. There are numerous reasons for selecting these third-party papers, including cost, paper weight, surface, and so on. Keep in mind that, if you use any of these third-party papers, the color may not reproduce correctly and may require you to either create your own custom profile (as discussed next) or obtain one from the paper supplier, if available.

With that all said, we can now load the paper into the printer. To create a custom printer profile for our paper, we will need a software application that will create a printer profile and a device to measure this target. For this example, we are going to use an Eye-One Spectrophotometer and ProfileMaker software, both from GretagMacbeth. Each measuring device needs its own target, so let's navigate to the proper folder, *ProfileMaker Pro 5.0.0/Testcharts/Printer/Eyeone*. Because we are using the standard Epson printer driver, we will need to pick an RGB target. But isn't the printer a CMYK device? Yes, the printer is a CMYK device, but the

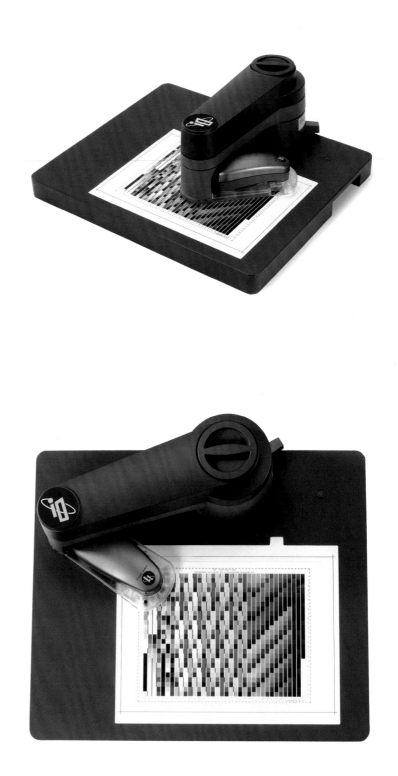

Epson printer driver converts the RGB file to CMYK. If you send a CMYK test target, you will be unable to create a proper profile (unless you use a RIP that allows you to send CMYK targets; see the previous section on RIPs for CMYK profiles). For the target, we'll pick one of the TC9.18 RGB targets, which has 918 color patches. There are other RGB targets with fewer patches, but they do not yield as high a quality profile. After all, aren't you trying to create the highest-quality image? The 918 targets come in several flavors, formatted for different page sizes depending on your printer. Because we are working with an Epson 4800 printer with 16-inch roll paper, we'll pick the one labeled TC9.18 RGB i1.tif to save paper and ink.

We'll print this target from Photoshop. It's important that the Color Settings in Photoshop are set properly. When you open this image, you should see a dialog pop-up telling you that this image does not have an embedded profile. We'll open it up "as is," because we don't want to change the values of this target. Next, go to "Print with Preview" to turn off any automatic settings or color management, which would skew our results. It is also extremely important that we print the file out at 100 percent. If we change the size, we'll most likely receive error messages when we try to read this target later on in the profiling software.

There are a few more settings that you should be aware of in the printer driver. In the print dialog box, the third button from the top gives you many different options, but we are only concerned with two, Print Settings and Printer Color Management. The options in Print Settings that you will use are Media Type, Color, and Mode/Print Quality:

Media Type

This refers to the type of paper that you are using. If you are using Epson paper, just pick that. However, if you are using a third-party paper, then you will need to pick a Media Type that is closest to Epson paper. Each Media Type has been optimized for different paper types and takes into consideration the amount of ink the media takes and how the tones are distributed on the paper. It may take some experimentation with different Media Types to find the one that works best for your third-party media.

Color

You have the option of either printing color or black and white. Pick Color since we are creating a color profile.

Mode/Print Quality

Select the Advanced Settings option, and pick the Print Quality that is the printer resolution. You may want to experiment with different settings here and determine what resolution works best for you. Some papers, such as luster and gloss, may need to printed at a high resolution, while other papers, such as matte and canvas, may look fine at a lower resolution. Keep in mind that the higher the resolution,

the longer it takes to produce a print. Sometimes you may want to make a compromise between speed and quality.

The second option in the printer driver that you need to know about is Printer Color Management. There are three options here, and you will want to select Off (No Color Adjustment).

You should realize that every time you change any of the these settings in the print driver, you are affecting the color, so you should make sure to use these exact same settings for each media that you create a profile for. Also note that you will need to create separate profiles for different resolutions. To spare you the trouble of going through all the options in the printer driver each time you print, you can save these settings in a preset. When saving the preset, be sure to use a naming convention that is descriptive and includes information such as the printer, paper, and resolution. A good name in this case would be 4800PremLust1440. Keep the name short so that you can see the entire name in the Presets window.

After the printer has printed the target, make sure that there are not any problems, such as marks, lines, or any other physical anomalies. Because inks take a while to stabilize, it's best to let the inks thoroughly dry before you measure the patches. For an Epson printer that uses pigmented inks, you should allow the paper to dry for 15 minutes. (As we noted in Chapter 4, if you are printing to a dye-based printer, it may take up to 24 hours for the patches to stabilize.)

Now you are ready to launch the ProfileMaker software so that you can create the profile. Because you are creating a printer profile, select Printer and then the target data TC9.18 RGB i1.txt for the corresponding target that you just output. Be sure that you have plugged the Eye-One into your computer. Next, select the Eye-One Pro as the measuring device for reading the target in the Measurement Data window.

ProfileMaker will then ask you to calibrate your instrument. This will lead you into the measurement window, where you can read the patches into the software. The Eye-One device allows you to read an entire strip (row) in at a time, which is much faster than reading the patches in one at a time. Take your time reading the patches. If you scan too fast, too slow, or too erratically, you'll receive an error message and have to reread the strip. With a little practice, you'll get the feel of the instrument, so don't get discouraged in the beginning if you have a few errors. The software will prompt you as to which line to read.

After you have read in all the patches, which should take about 15 minutes, the software will inform you that you have successfully read your patches. When you close the window, you'll be prompted to save the data. Save your file in the *Measurements files* folder, which is found in the *ProfileMaker* folder. Again, be sure to use a descriptive name.

This data that you just saved will now appear in the Measurement Data window. If it doesn't, navigate to the folder where you saved the data and load the file. The software has numerous options for creating a profile. Based on my

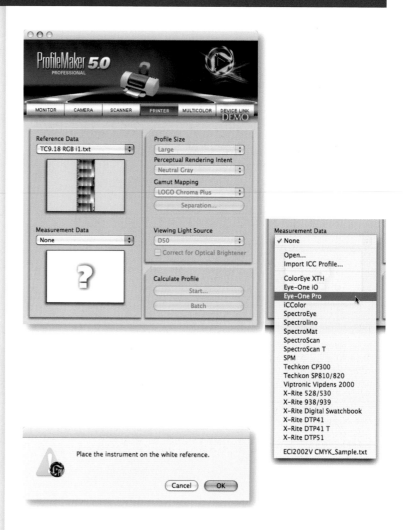

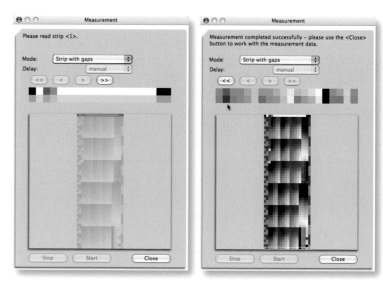

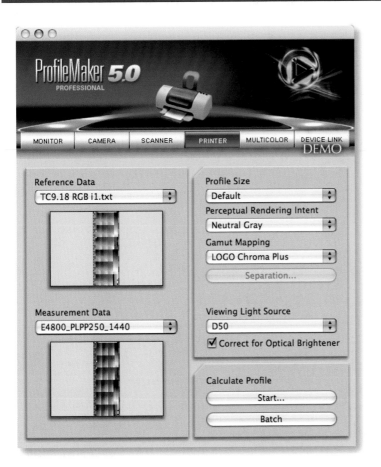

experience, I suggest you use the settings that appear by default as a starting point. Feel free to experiment and find what works best for you.

Two settings that you should be aware of are "Viewing Light Source" and "Correct for Optical Brightener." The Viewing Light Source is relatively unique to this particular application; it allows you to change the overall color of the profile to compensate for the viewing conditions. Use D50 as your default because it is a lighting standard in the United States. If you are viewing under other lighting conditions, pick the one that is closest to what you are using. "Correct for Optical Brightener" will become available if the paper that you are using has a UV optical brightener to make the paper appear whiter. As discussed in Chapter 4, in order to make a paper appear whiter, the UV brightener is actually made more blue and therefore needs to be compensated for when creating the profile. Some spectrophotometers have a UV filter on them to prevent this from being a problem. However, if you encounter a paper with a UV brightener and your measuring device does not have a UV filter, this checkbox will be available and you should select it.

You are now finally ready to create your profile. Give it the same name as your measurement data so that you don't become confused. The next step is to use this profile to produce a great print.

Some Final CM Thoughts

As you've seen from the examples in this book, there are many different workflow situations in which you might be working. The one you pick will very much depend on how you like to work and how much work you have.

We've covered some simple scenarios in this book, but consider all the possible complexities. Input could come from client files, different digital cameras, and scanners. Add to the mix a variety of different applications, such as BibblePro, Photoshop, InDesign, QuarkXPress, and DreamWeaver. Then, consider outputting these images to the Internet, printing presses, and different ink-jet printers. It quickly becomes apparent that there are many different color management scenarios. The key to implementing the right color-managed workflow is understanding the concepts of how color management works. With the knowledge that you have gained by reading this book, you should have a good foundation for setting up color management with a number of applications and devices, including those not covered in this book. You always have the option of using outside sources—such as dealers, vendors, consultants, colleagues, and trade organizations—to assist you in implementing a complex color management system. And we've listed some resources in the Appendix.

THE FUTURE OF COLOR MANAGEMENT

As with many things in life that get faster, cheaper, and easier, color management is no exception. Fifteen years ago, color management was in its infancy. There were a limited number of products, the cost was high, it didn't always work very well, and it was difficult to fit into the workflow.

It really wasn't until the ICC was formed that color management came to exist as we know it today. The ICC represents an open set of standards that will work with many different devices and software applications, and across different computer platforms. Is the ICC perfect? Far from it. The ICC standards are in a constant state of flux. Within the ICC, there are several committees representing disparate industries, including photography, motion picture, graphics arts, and others.

Color management is being constantly improved within the various applications that we use. Is it always easy to use? Obviously, no. Even though many programs use ICC profiles, they don't always implement them in the same way. It's often not intuitive to the user how color management is really working.

For color management to be used more, it needs to become more automated and less expensive. In its current state, you have to be extremely careful and make sure that everything is just right. Manufacturers are slowly doing a better job of supplying profiles for their devices. However, the biggest stumbling block is calibration. Devices drift over time, and calibration varies from device to device. Currently, it is neither economical nor logistically possible to calibrate all devices. Most desktop printers do not have any means of calibration.

In the future, manufacturers could design printers that could calibrate themselves, and that include profiles. It should be possible for a manufacturer of a printer to produce very accurate color. (Of course, all bets will still be off if you use third-party ink and media, which will still require you to calibrate the device yourself or find someone else to do it for you.)

Monitors still need to be calibrated and profiled because they change over time. The only way to do this is to measure the color of the actual monitor itself. Years ago, Apple made a ColorSync monitor that was supposed to calibrate itself and use its own profile. Apple knew that its monitor would change over time, so the company built in circuitry that tracked the amount of time the monitor was on and compensated for color and brightness changes over time. It worked reasonably well, but it was not completely accurate. In the future, most monitors will include a built-in sensor that will keep it automatically calibrated and profiled.

Digital cameras are probably the most difficult devices to profile accurately because of limitations in the targets we use today. New targets are currently in development; instead of being a set of color swatches on paper, these targets will be an array of color lights with a much wider color and dynamic range. With this new type of target and better software to handle this greater range, it would be feasible for manufacturers to supply different profiles for their cameras. However, in the real world, there will always be different light sources and environments, and cameras will still need to be calibrated (white balanced). But maybe we'll see a method for making calibration easier in the future.

In conclusion, color management works today, but for many it doesn't work as well or as easily as you would expect. It's come a long way from the past, and it's getting better and easier all the time. As with any technology, there is not a right or wrong time to adopt color management. The best time to jump in is when you need it.

Additional Color Management Resources

Throughout this book, we've taken a practical approach to showing you the fundamentals of color management that you'll need to get consistent color results. You've probably noticed that we've admitted color management can be a very intricate subject, with more complexities than many people ever want or need to know. If you do want to know more, this chapter offers some key resources that we think will be valuable in continuing your color management education.

Contents

Appendix

UPDIG Guideline Excerpts

UPDIG refers to the Universal Photographic Digital Imaging Guidelines, a set of best practices for digital photography that have been put together by a group of working photographers, manufacturers, and trade groups. Included here are some UPDIG excerpts that are relevant to color management.

The following is an excerpt from the guidelines available at *http://www. updig.org*. Used with permission.

The Primary Goals

- Digital images look the same as they transfer between devices, platforms, and vendors.

- Digital images are prepared in the correct resolution, at the correct size, on the devices(s) on which they will be viewed or printed.

UPDIG Guidelines for Meeting the Goals

1. **Manage the color.** ICC profile-based color management is the standard.

2. **Calibrate the monitor.** Monitors should be calibrated and profiled with a hardware device.

3. **Choose a wide gamut.** Use a wide-gamut RGB color space for capturing and editing RGB master files. We recommend Adobe RGB (1998) or ProPhoto RGB.

4. **Capture the raw data.** For best quality, digital cameras should be set to record RAW files.

5. **Embed the profiles.** All digital files should have embedded profiles (should be "tagged"), unless otherwise noted. Photoshop's Color Management should be set to "always preserve embedded profiles" and the "ask when opening" boxes should be checked to alert you to profile mismatches and missing profiles. When profile mismatches occur, you should elect to preserve the embedded profile.

6. **Color space recommendations:**

 a. For the Web, convert images to sRGB and embed sRGB profile before delivery.

 b. For display prints from professional digital color labs, if a custom profile is available, use it for soft proofing. Then submit either sRGB or (more rarely) Adobe RGB with embedded profiles, as specified by the lab. If a lab does not have a custom profile, it's usually best to use the sRGB color space with that profile embedded.

 c. For display prints from many consumer digital-print vendors, a database of custom profiles is available. Otherwise, deliver files in the sRGB color space with embedded profile.

 d. For offset printing, it's always best to begin by asking the printer or the client's production expert what file format, resolution, and color space they require. RGB files contain many colors that cannot be reproduced by conventional CMYK printing. This has often led to a situation where the final result looks nothing like the screen version of the file, or the ink-jet print of the file. There are two ways to avoid this confusion:

 - Files can be delivered as CMYK files. This is the "safe" way to go, because the image itself will contain no colors that can't be reproduced by the CMYK process.

 - Files delivered as RGB files can be accompanied by a cross-rendered guide print that includes only colors reproducible in CMYK.

 Files can also be delivered in both CMYK and RGB. This allows the photographer to make the artistic decisions about color rendering, and gives the printer more tools to recover from mistakes the photographer may have made in converting RGB to CMYK.

Ideally, CMYK image files should be converted from RGB using the printer's CMYK profile with that profile embedded in the file. It is not always possible to get the printer's profile, either because the printer does not have one or the client does not know who will print the images. In such cases, it's often best to deliver an RGB master file, with an embedded profile and a ReadMe file that explains that "for accurate color, the embedded RGB profile should be preserved" when opening the file.

e. For ink-jet and dye sub printers, use a wide-gamut color space, such as Adobe RGB, for the source space. Use a custom profile for the printer-paper combination in the print space to get the best quality and the best match to a profiled monitor.

7. **Formats and names.** File formats should always be denoted by standard, three-letter file extensions.

 a. For the Web, use JPEG files.

 b. For print, uncompressed TIFFs are best. Use JPEG only when bandwidth or storage constraints require it. Use the highest JPEG quality setting possible. We recommend not using less than "8" quality.

To avoid problems with files that will be transferred across computing platforms, name files with only the letters of the alphabet and the numerals 0 through 9. Avoid punctuation marks (other than hyphen and underscore), accented vowels, and other special characters. Keep the full name (including extension) to 31 characters or less for files on a network or removable media and to 11 characters or less (including the three-letter file extension) when burning to CD-R, in case a recipient's computers don't support long filenames. For the complete guide to file naming protocol, see the Controlled Vocabulary website (*http://www.controlledvocabulary.com/imagedatabases/filename_limits.html*).

8. **Appropriate resolution.** Resolution of digital images is described by three numbers: height, width, and ppi (pixels per inch). Beware: it's easy to confuse ppi with dpi (dots per inch), which refers to the resolution of a printing device, or with lpi (lines per inch), which describes a halftone grid or screen used for printing images on a press.

The following target resolutions are meaningful only when paired with the height and width at which an image will appear in the final form:

 a. Low (monitor or "screen") resolution is defined as less than 100 ppi.

 b. Ink-jet prints normally need resolutions of 180–360 ppi.

 c. Continuous-tone printing requires resolutions of 250–400 ppi.

 d. The offset-printing standard is often considered 300 ppi. But resolutions of 1.3–2 times the halftone screen for the project are considered safe. If the images will be printed at 150 lpi, the appropriate image file resolution range would be 195–300 ppi.

9. **Sharpen last.** All digital images require sharpening, during capture or after, and the correct amount to apply depends on the type of use and size of the final output. For most uses, it's best to sharpen little or none during capture with a camera or scanner. Sharpening is an art, and requires study and practice. There are several schools of thought regarding proper sharpening. One recommended method is to remove capture softness using a gentle sharpening pass followed by local sharpening and/or output sharpening. Sharpening should be the final step in reproduction, because resizing and contrast adjustment affect an image's sharpness. Sharpening is best evaluated at 100 percent and 50 percent views on your monitor, or by making a print. The most common sharpening method is to apply an "unsharp mask" filter (higher settings for higher-resolution files) to images, but other sharpening methods and Photoshop plug-in programs can be useful, too. Oversharpening creates obvious halos around edges within images.

10. **Delivery.** Digital image files may be delivered on removable media (removable hard drive, CD-Rs, or DVD-Rs), or via File Transfer Protocol (FTP) or email. If files are delivered on CD-R, the standard disc formatting is ISO 9660 or "Mac OS extended and PC (Hybrid) CD." When delivering images on a DVD-R,

make sure the recipient can read the chosen format, since there are multiple standards. Often speed and convenience require delivery by FTP. Although not a preferred method, email delivery usually works if image files are small in number and size, and both sender's and recipient's Internet service providers permit large attachments. Email delivery sometimes works better if the image files are first compressed using RLE compression software such as WinZip or StuffIt. Check to make sure the recipient can access your specific version of compressed files. Delivery by FTP or email usually precludes delivery of a "guide print" (discussed later in this Appendix), so a disclaimer should always be included that states accurate viewing and reproduction depend on the recipient properly applying ICC color management.

11. **File info**. All digital image files should have embedded metadata—including copyright, usage license, and contact information—that conforms to the IPTC or the newer IPTC Core standards (*http://controlledvocabulary. com/imagedatabases/iptc_naa.html*). Photoshop users can input and edit this information by choosing "File Info" under the File menu. Adding caption, title, origin, and keyword data enhances searches and organization with digital asset management applications.

12. **Describe what's there.** Provide a ReadMe file in either PDF, HTML, or TXT format with all files delivered for output. Such files should specify image size(s), color space(s) and any licenses granted, the copyright owner's contact information, and, if certain rights are being withheld, the words "other uses, reproduction or distribution are specifically prohibited." The ReadMe file should also include disclaimers noting recipients are responsible for following an ICC-based color management workflow.

13. **Send a guide.** Whenever possible, include a guide print with digital image files. A guide print is typically an ink-jet print that serves as a color reference for reproduction of a digital image file.

14. **Disk labels.** Do not use adhesive labels on optical media, since they may separate and damage an optical drive. Printing directly on ink-jet-writable CD-Rs or DVD-Rs is a good way to provide information such as your copyright, usage license, file lists, and disclaimers.

15. **Long term.** Archiving responsibilities should be clearly stated in writing for everyone involved. Photographers should note that charging for archiving could mean assuming liability for maintaining such archives. Prudent photographers keep backups on external magnetic drives, as well as on optical media and, if possible, also keep duplicate backups offsite.

UPDIG Guidelines: Supplemental Information

Monitors

Computer monitors must be calibrated and profiled before they can be part of a professional workflow. Accurate monitor calibration and creation of a display profile requires a hardware device, such as the GretagMacbeth Eye-One, Color Vision Spyder2, or Monaco Optix XR. Another useful tool is a Profile Verification Kit. This is a digital file with an accompanying proof or print. After profiling your monitor, you view a comparison between the digital file displayed in Photoshop (or other professional-imaging software), and the proof print, as viewed under 5000K/D50 lighting, to indicate whether your monitor profile is accurate.

There are two types of display technology in use today: cathode ray tube (CRT) and liquid crystal display (LCD). CRT displays are rapidly being replaced by LCD monitors. In fact, professional-grade CRTs are no longer being made.

- CRT monitors should be calibrated before they are profiled since they have hardware controls that affect the RGB amplifiers as well as controls for black level and luminance. The hardware device and software are used first to adjust the RGB guns to the desired white point (color temperature) and black point (if available on your display system), and then the calibrated CRT is profiled. The display profile is then used by color-savvy programs such as Photoshop to display accurate color.

- LCD displays often only have brightness controls, although some also have a contrast control. Some

LCDs have color temperature controls; however, they actually only adjust the CLUT (color lookup table) and, if much different from the native color temperature, can cause reduced color gamut and banding. For that reason, when profiling an LCD, it is best to adjust only the brightness control and contrast control, and let the profiling device set the desired white point through the display profile.

- **DDC (direct digital communication) allows for the brightness, contrast, white point, and gamma to be adjusted through the profiling device and software. This will save time and improve precision when calibrating and profiling monitors. When shopping for a new monitor, it's best to choose a DDC-compliant display, if possible.**

In choosing white point and gamma settings, the whole concept of monitor calibration and profiling is to create a situation where the image on your monitor is a close match to the image as a print, a proof, a press sheet, or if your work is destined for the Web, as viewed on the average uncalibrated PC or Mac monitor. The white point may range from 5000K (more yellow/red) to 6500K (bluer), and the gamma may vary from 1.8 to 2.2. The luminance may vary from 80 cd/m² to 140 cd/m². There is not a single standard for white point, gamma, or luminance because there is not a single standard for what you are trying to match. If you are working in prepress, you will want to match press proofs and press sheets. For this, you may find that a white point of 5000K or 5500K and a gamma correction of 1.8 will give you the best match of monitor to proof or press sheet as viewed under a 5000K light or booth. The appropriate luminance may be around 100 cd/m². If you are preparing files for ink-jet or light-jet printing, you may find that a white point of 6000K or 6500K will give you the closest match, although you should always view the prints under the color temperature of the lighting that will be used to view them. One reason that a higher (bluer) white point often works best for display prints is because optical brighteners are often used in display print media. Once again, monitor luminance should be chosen to match the appearance of the display prints in the viewing condition. The gamma correction (1.8 lighter, 2.2 darker) should also be evaluated with the viewing conditions and the contrast characteristics

of the printer in mind. Image files being prepared for the Web should be prepared to the sRGB standard gamma of 2.2, and a white point of 6500K. This will be a compromise between the uncalibrated Mac gamma standard of 1.8 and the uncalibrated PC standard of 2.4. It is also a reasonable compromise between a prepress monitor calibrated to 5000K, and an uncalibrated PC monitor, which may be in the 7300K–9300K range.

For native white point, there is a good argument for keeping things simple with the current crop of LCD monitors, and simply profile using native color temperature, and native gamma, and letting your eyes adjust to the difference between the monitor and the print/proof. The strength of this argument is that using this method will ensure that you get the widest dynamic range the monitor can produce, and also minimize artifacts, banding and posterization, which can occur the farther you force a monitor (especially an 8-bit monitor) from its native white point and native gamma. If you do choose a custom white point and gamma, it is a good idea to evaluate the resulting profile with a utility such as those found here:

- http://www.drycreekphoto.com/Learn/Calibration/ monitor_black.htm

- http://www.drycreekphoto.com/Learn/Calibration/ monitor_gradient.htm

There are more choices than gamma 1.8 and 2.2. Some calibration software allows you to choose a custom gamma. Other software allows you to edit the gamma curve, and one software, ColorEyes, has something called L* gamma, which is unique to that software. L* creates separate tonal curves for the shadow areas, midtones, and highlights, providing smoother transitions, and therefore more accurate color reproduction (http://www.integrated-color.com).

The current LCD technology uses a white fluorescent backlight. NEC has produced a new type of LCD that uses red, green, and blue LEDs (light-emitting diodes) that combine to produce a white backlight. The advantages are a wider color gamut, greater dynamic range, and the ability to adjust the white point without compressing the color gamut. NEC offers a white paper that explains this new technology and its advantages (http://www.necdisplay.com/ corpus/S/6/LCD2180WG-LEDTechPaper_121605.pdf).

Working environment is critical. No matter how good your monitor or how well you have it calibrated and profiled, you must take care that your working environment is subdued neutral lighting that does not vary throughout the day. Your computer desktop should be set to a neutral gray, and you should avoid having areas of bright color within your field of vision, or reflected in the monitor.

Cameras

Professional digital cameras have selectable color spaces. Photographs intended for print should be captured in a wide-gamut space, such as Adobe RGB (1998). Photographs intended only for the Web can be captured in the narrower-gamut sRGB color space. It is possible, but not strictly necessary, to create custom camera profiles. When such profiles work, they can speed workflow and yield more accurate colors. Adobe's Camera Raw program allows for calibration of a digital camera, creating in effect a custom profile.

It's essential that a photographer choose the correct color profile when capturing JPEGs or TIFFs, because the camera will process images into these formats using the specified profile.

Capturing images in a RAW file format offers post-production flexibility to create the best-quality images. Photographers capturing RAW files can choose color space, white balance, and to some extent, exposure value (ISO speed setting) after the capture via the image-processing software. In addition, many RAW processors have sizing algorithms that (some say) are superior to interpolation in Photoshop, since they are working with the RAW data—the actual pixel data captured by the camera's imaging sensor. RAW files also offer more bit depth than JPEG files, allowing more aggressive editing, both in the RAW software and when imported as 16-bit files in Photoshop.

Many camera manufacturers have created proprietary, undocumented RAW file formats. Adobe has offered an open source RAW file format called Digital Negative (DNG). If adopted by camera makers, it would create a standard RAW format that would simplify access to older RAW files as we move into a future of changing software and filing systems. A good first step would be for camera makers to provide

open documentation of their RAW file formats. In the meantime, many photographers are converting proprietary RAW files to DNG format before archiving.

Digital cameras and digital-imaging software programs are evolving rapidly. Signal-to-noise ratios continue to decrease, yielding cleaner, higher-quality files at a given megapixel rating. Interpolation algorithms are improving. This makes it unreasonable to specify a certain megapixel rating as a minimum standard tied to any given file size or printed output size.

Scanners

Scanning software, like that for digital cameras, allows a choice of color space for the resulting files. A wide-gamut space for print (such as Adobe RGB) and the smaller sRGB color space for web are the standards. In addition, a scanner should be profiled for maximum color accuracy.

Print or proof-viewing area

The ideal standard is a viewing booth with a dimmable D50 light source. Alternatives to a viewing booth are halogen lights rated at 4700K or 5000K, or full-spectrum fluorescent lights rated at 5000K. A Profile Verification Kit includes a print that incorporates a GATF RHEM light indicator, which indicates whether your viewing area is D50. The inside-back cover of *Real World Color Management* by Bruce Fraser, Chris Murphy, and Fred Bunting (Peachpit Press) also has a GATF RHEM light indicator.

Professional digital color labs

Most professional digital color labs that do have an ICC workflow usually require sRGB as the color space to send to their RIP or other printer software. A few labs will work from Adobe RGB files, so it is best to ask before submitting files. Those labs that offer custom profiles provide them as "soft-proofing" profiles only, since they update their actual profiles on a regular basis, when they change chemistry, paper batches, or software versions.

Consumer photo lab digital printers

There is a free database of ICC printer profiles for digital labs worldwide at the Dry Creek Photo site (*http://www. drycreekphoto.com*). The printers covered include Fuji Frontier, Noritsu, Agfa D-Lab, LightJet, Durst, and Chromira

printers, among others. Because these printers do not recognize embedded profiles, it is necessary to convert your files to their profiles, and then save them with the profiles embedded. Converting to these profiles will give you the best color fidelity and allow you to soft-proof your digital files before committing them to print. Labs that don't use profiles usually require that submitted files be converted to sRGB. To avoid confusion on your end, it's still best to include the embedded profile, even if the lab will ignore it. Using the sRGB color space instead of a custom profile may yield less accurate color that doesn't take advantage of the full gamut such printers can produce.

Offset printing

We strongly recommend that all offset printers adopt the ICC standards. Currently, there is tremendous variation among offset printers, and nothing can be taken for granted. For many years, offset printers used a "closed loop" color management approach. They scanned film on drum scanners with software that output directly to CMYK. The CMYK was targeted to a proofing device, the customer approved the proof, and the press was adjusted until its output matched the proof. Color profiles were built into the workflow, not applied to files. This meant printers could not offer custom CMYK profiles for digital files created outside their shops.

Today, with 60 to 80 percent of images intended for print arriving as digital files, offset printers are moving away from the closed-loop workflow. A single printed piece often includes digital image files from many different sources. It is increasingly likely that an offset printer will have a CMYK profile that describes its proofing device's color space. As a general rule, an offset printer can match the output of its proofing device.

Two organizations in the United States have produced standards for the printing industry that would allow for standardized CMYK profiles. They are the SWOP Committee (Specifications for Web Offset Publications), covering web presses, and GRACoL (General Requirements for Applications in Commercial Offset Lithography), which covers sheet-fed printing. The two standards, SWOP TR001 and GRACoL's DTR004, if widely adopted, would do away with the need to worry as much about custom CMYK formulas.

Outside of the U.S., organizations such as The European Color Initiative are working to support similar standards, such as ISO 12647.

When a photographer has the expertise, it's best to provide the printer with CMYK image files embedded with the printer's custom CMYK profile. If the printer does not have a custom profile, it's best to consult with the printer or the client's production expert to determine the best color space for the delivered files. A standard Photoshop CMYK profile that matches the general press conditions—sheet-fed coated or uncoated, or web coated or uncoated—may suffice, particularly if the printer adheres to SWOP or GRACoL specifications. In this period of flux, communication is key.

Many times, digital image files must go to several different printers, or a project is photographed and delivered before a printer has been chosen. In such cases, it may be best to deliver RGB master files. These should always have an embedded RGB profile to ensure accurate color when they are converted to each printer's specific CMYK profile.

Send RGB image files (especially Adobe RGB) to a printer only if the shop has experience converting RGB files to CMYK—and then only if the printer will provide a random or contract proof. If a printer has a clear understanding of ICC profiles and requests RGB, it's best to submit files in Adobe RGB or, possibly, the narrower-gamut ColorMatch RGB. If a printer cannot ensure preservation of the embedded profile before converting to CMYK, it is better to provide files converted to a general-purpose CMYK or RGB profile, such as SWOP Coated V2 CMYK, ColorMatch RGB, or sRGB, with the appropriate profile embedded in the file.

Besides color profile issues, perhaps the biggest stumbling block to quality reproduction is inappropriate file resolution. Some digital cameras produce a native file at x inches high by x inches wide at 72 ppi. This sometimes results in printers receiving files of the correct height and width, but at 72 ppi. This mistake is so common that printers have a mantra that all files need to be 300 ppi when the image is sized to the final height and width to be printed. This can be used as a rule of thumb, although if you have good communication with a knowledgeable printer, you can use the more sophisticated standard of 1.3 to 2.0 times the halftone screen ruling (lpi) for the job.

RGB master files

RGB master files are Photoshop (PSD) or TIFF files, optimized in a wide-gamut color space (such as Adobe RGB or ProPhoto RGB), at either at the digital camera's native file size or interpolated to a larger size (consistent with any possible future use) by a RAW file conversion program. They should be left unsharpened or sharpened only on a removable layer, since resizing for future uses is likely. Master files should be archived along with the RAW files for a project.

Ink-jet and dye sub printers

You can easily bring desktop and wide-format printers into a color-managed environment with the help of profiles. If working with the manufacturer's printer driver, turn off all color management and print a copy of the color target file. Next, measure the printed target with a spectrophotometer to generate a profile for accurate output on a particular paper or other medium. Repeat this process for each paper stock you use. Most RIP (Raster Imaging Processor) software offers profiles for a wide variety of papers. Many RIPs will also allow use of custom profiles.

Guide prints

Profiling a desktop printer is critical for photographers who include digital guide prints with their digital files—a key part of these guidelines. This is particularly true with CMYK files submitted to an offset printer. Unless using a SWOP-certified proofing system, photographers should include disclaimers stating that guide prints are for color reference only and are not "contract" proofs.

Since ink-jet guide prints made from RGB editing spaces may have wider color gamuts than available from an offset press, a guide print will more accurately reflect what is possible to achieve on an offset press if it is "cross rendered." Cross rendering involves printing from your current output color space through an intermediate output color space to simulate the appearance of the final output space. For example, in the print dialog, the "source" space would be either the CMYK file or the CMYK proof space. Choosing Relative Colorimetric as the rendering intent will limit a desktop printer's color gamut to the gamut of the CMYK file. If you use Absolute Colorimetric (or check the "simulate paper color" box in Photoshop CS2), you may more closely simulate the actual press sheet, since the whites will more closely match the duller white of the actual press stock.

Photoshop's settings for cross-rendering a print can be found in the Print With Preview dialog. Note that Photoshop CS1 does not have the "simulate paper color" checkbox.

A guide print should not be confused with or referred to as a "proof." That term refers to a "random" or a "contract" proof, provided by an offset printer or prepress house, and created from the actual films or plates used for press output. Direct-to-plate workflows create proofs with special printers, calibrated RIPs, and special proofing media to closely simulate the actual press conditions. "Contract proofs" are considered guarantees by printers (or prepress houses) that press sheets will match the proofs.

A SWOP-certified proof provides additional precision when indicating the color of digital files delivered to an offset printer. SWOP-certified systems combine RIP software driving special proof printers. More information on SWOP-certified systems is available.

Workflow

No single workflow suits all photographers or all clients. The ideal workflow should provide the best combination of quality and services to fit a client's budget and needs. Because digital photographic imaging is relatively new, photographers must regularly explain to clients the trade-offs between quality and cost in different workflows.

A film-based workflow is simple. Photographers deliver film, designers or art directors decide how pictures will be used, and offset printers and prepress houses handle conversion of the film to printing plates.

Digital cameras, along with scans from film by photographers and agencies, are now replacing film workflows. While clients have been quick to embrace the speed and convenience of digital capture and delivery, they do not universally understand what is required to achieve the same quality levels that they used to expect from film. With the exception of those involved in high-volume, quick-turnaround workflows, most photographers must decide how to handle file preparation. Some photographers want to avoid the distraction of file preparation. Others have embraced it, because it allows powerful control over the

reproduction of their images. Profiles and soft proofing allow photographers to see how their files will look as display or press prints. Looking at soft proofs on their calibrated monitors, those who embrace file preparation can deliver to printers files that will accurately (if not precisely) reproduce on paper the optimized image files the photographers see on their monitors.

When you send an RGB file to an offset printer, the biggest risk is that a prepress worker will open it in the wrong RGB color space, altering the color, and then lock in the mistake by immediately converting the file to CMYK. If the printer receives an untagged RGB file, and there has been neither communication with the printer nor the inclusion of a ReadMe file that indicates the color space of the files, prepress will probably open the file in the shop's default RGB space, which may or may not be the space in which the file was optimized. Even when an image file is correctly tagged and its profile preserved when it's opened, there may be problems if a printer uses a RIP for CMYK conversion. Most RIP software does not use black point compensation, and without it, some conversions can appear flat and unsaturated (muddy).

FOR MORE VALUABLE UPDIG INFORMATION

The material here has been excerpted from the UPDIG Guidelines version 1.0. (September 2005). For the most recent version, please check www.updig.org. UPDIG members include:

- **Australian Commercial and Media Photographers**
- **Advertising and Illustrative Photographers Association (NZ)**
- **Association of Photographers (UK)**
- **Advertising Photographers of America**
- **American Society of Media Photographers**
- **American Society of Picture Professionals**
- **Canadian Association of Photographers and Illustrators in Communication**

- **Editorial Photographers**
- **International Digital Enterprise Alliance**
- **Museum Computer Network**
- **National Press Photographers Association**
- **Picture Archive Council of America**
- **Picture Licensing Universal System**
- **Professional Photographers of America**
- **Stock Artists Alliance**

Additional Resources

Here are some books and web resources that we find particularly useful if you want to sink deeper into color management geekdom.

Books

- *Color Confidence: The Digital Photographer's Guide to Color Management* **by Tim Grey (Sybex, 2006)**

- *Color Management for Photographers: Hands on Techniques for Photoshop Users* **by Andrew Rodney (Focal Press, 2005)**

- *Real World Color Management*, Second Edition, **by Bruce Fraser, Fred Bunting, and Chris Murphy (Peachpit Press, 2004)**

- *Understanding Color Management* **by Abhay Sharma (Thomson Delmar Learning, 2003)**

Websites

Articles, training

www.photoshopnews.com
Latest news about the top pixel-wrangling application on the planet

www.brucelindbloom.com
Great site for color geeks who want to know how color works

www.chromix.com
Resource for hardware, software, and remote profiling

www.color.com
Parent organization for the International Color Consortium

www.creativepro.com/author/home/40.html
Source for books and articles by color guru Bruce Fraser

www.digitalattributes.com
Color management and workflow consultants (Rick Lucas)

www.digitaldog.net
Andrew Rodney site for color information, articles, and so on

www.dpreview.com
Great website on digital photography

www.ipa.org/tech/color_management.php3
Articles on color management

Articles, information

www.openraw.org
Group of photographers who are trying to open up documentation of different RAW formats

www.photo.net
Large site dedicated to photography

www.photographyblog.com
Photography news, reviews, articles, and so on

www.robgalbraith.com
Great website on digital photography

www.updig.org
Group of imaging professionals working on promoting universal standards for commercial digital imaging

Trade Journals

Adobe Magazine
www.adobemag.com

Digital Camera Magazine
www.dcmag.co.uk

Digital Output Magazine
www.digitalout.com

Photo Techniques
www.phototechmag.com

Professional Photographer
www.ppmag.com

Shutterbug
www.shutterbug.com

Trade Associations

American Society of Media Photographers (ASMP)
www.asmp.org

Photo Marketing Association International (PMAI)
www.pmai.org

Professional Photographers of America (PPA)
www.ppa.com

Advertising Photographers of America (APA)
www.apanational.com

National Association of Photoshop Professionals (NAPP)
www.Photoshopuser.com

Manufacturers

www.bibblelabs.com
Camera RAW-processing software

www.colorvision.com
Color management hardware and software

www.gretagmacbeth.com
Color management hardware and software

www.icscolor.com
Color management software

www.kodak.com
Color management software and articles

www.phaseone.com
Camera RAW-processing software

www.pictocolor.com
Color management software

www.xrite.com
Color management hardware and software

Podcasts

A new source of great information on digital photography, color management, or anything else for that matter can be obtained by subscribing to a podcast. Podcasting is a way to publish files to the Internet so that anyone may subscribe and receive (usually audio) files mostly for free. You can go to any search engine and type in "podcast" and find many sources for podcasts. There are many devoted to digital photography, and new ones are being created all the time. For this reason, there are no resources listed here because it would be out of date in no time.

Index

About the Author

Eddie Tapp is an award-winning photographer, lecturer, consultant, and author on digital imaging issues who has over 20 years of experience in computer technology. Eddie has shared his knowledge with a worldwide audience through a series of instructional videos (available from Software Cinema) addressing topics such as professional enhancement techniques, color management, and digital workflow, as well as through numerous contributions to publications such as *The Professional Photographer*, *Photo Electronic Imaging*, *Infoto Magazine*, *Southern Exposure Magazine*, and *Digital Capture*, among others.

Currently the Director of the Institute of Visual Arts in Maui, Hawaii, Eddie served for six years as the Chairman of the Committee on Digital and Advanced Imaging for the Professional Photographers of America (PPA), where he holds the Master of Photography, Master of Electronic Imaging, and Photographic Craftsman degrees, is an Approved Photographic Instructor, and is a Certified Professional Photographer. He also is the Commercial Council representative to the PPA for the Georgia PPA. Eddie serves on Adobe's Photoshop beta team and on the National Association of Photoshop Professionals' Photoshop Dream Team. *Practical Color Management* is the second in the "Eddie Tapp On Digital Photography" series from O'Reilly Media.

Eddie has been nominated to the Photoshop Hall of Fame.

Colophon

The cover image is an original photograph by Eddie Tapp. The cover fonts are Helvetica and Berthold Akzidenz Grotesk. The text and heading font is Myriad Pro; the Note font is Swister.

Better than e-books

Buy *Practical Color Management: Eddie Tapp on Digital Photography* and access the digital edition FREE on Safari for 45 days.

Go to www.oreilly.com/go/safarienabled
and type in coupon code 27HS-3LRH-2R47-D9G7-95EI

Search
thousands of
top tech books

Download
whole chapters

Cut and Paste
code examples

Find
answers fast

Search Safari! The premier electronic reference library for programmers and IT professionals.

Related Titles from O'Reilly

Photoshop

Adobe Creative Suite 2 Workflow

Adobe Photoshop CS2 One-on-One

Assembling Panoramic Photos: A Designer's Notebook

Creating Photomontages with Photoshop: A Designer's Notebook

Commercial Photoshop Retouching: In the Studio

Illustrations with Photoshop: A Designer's Notebook

Photo Retouching with Photoshop: A Designer's Notebook

Photoshop Blending Modes Cookbook

Photoshop Elements 3 for Windows One-on-One

Photoshop Elements 3: The Missing Manual

Photoshop Elements 4 One-on-One

Photoshop Elements 4: The Missing Manual

Photoshop Filter Effects Encyclopedia

Photoshop Fine Arts Effects Cookbook

Photoshop Photo Effects Cookbook

Photoshop CS2 Raw

Photoshop Retouching Cookbook for Digital Photographers

Photoshop Workflow Setups: Eddie Tapp on Digital Photography

Practical Color Management: Eddie Tapp on Digital Photography

Stephen Johnson on Digital Photography

Window Seat: The Art of Digital Photography and Creative Thinking